THE HISTORIAN'S EYE

THE HISTORIAN'S EYE

Photography, History, and the American Present

Matthew Frye Jacobson

Published by the

University of North Carolina Press, Chapel Hill,

in association with the

Center for Documentary Studies at Duke University

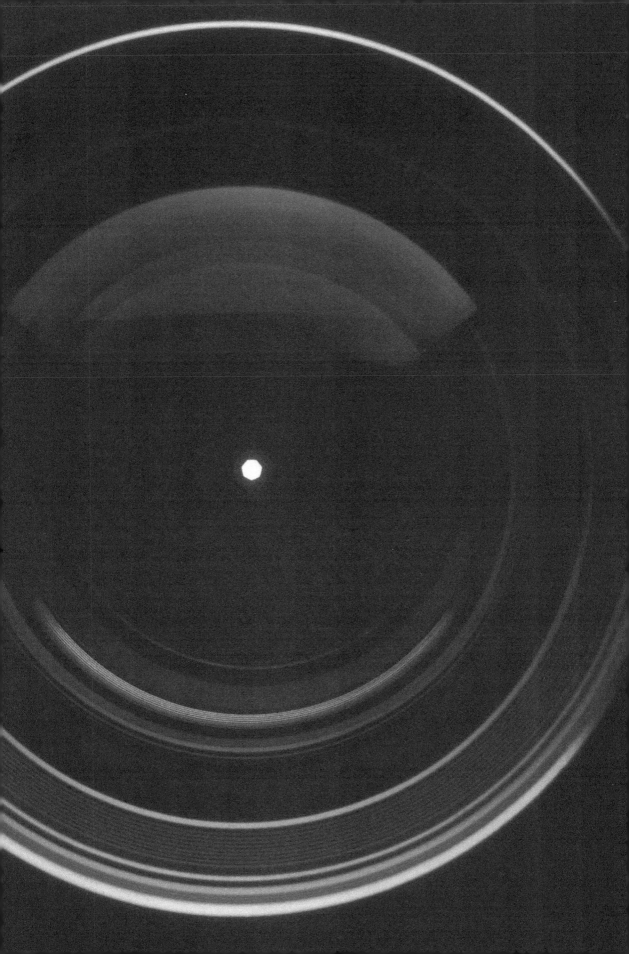

This book was published with the assistance of the William R. Kenan Jr. Fund of the University of North Carolina Press.

Designed by Kimberly Bryant and set in Whitman and DIN types by Tseng Information Systems, Inc.

The University of North Carolina Press has been a member of the Green Press Initiative since 2003.

Cover illustrations: collage of photographs by Matthew Frye Jacobson; *Isolated Shot of Professional Camera Lens against Black Background,* © iStockphoto.com/kyoshino.

DOCUMENTARY ARTS AND CULTURE
Edited by Alexa Dilworth, Wesley Hogan, and Tom Rankin of the Center for Documentary Studies at Duke University

In a time when the tools of the documentary arts have become widely accessible, this series of books, published in association with the Center for Documentary Studies at Duke University, explores and develops the practice of documentary expression. Drawing on the perspectives of artists and writers, this series offers new and important ways to think about learning and doing documentary work while also examining the traditions and practice of documentary art through time.

Library of Congress Cataloging-in-Publication Data
Names: Jacobson, Matthew Frye, 1958– author, photographer. | Duke University. Center for Documentary Studies, publisher.
Title: The historian's eye : photography, history, and the American present / Matthew Frye Jacobson.
Other titles: Documentary arts and culture.
Description: Chapel Hill : University of North Carolina Press ; [Durham] : in association with the Center for Documentary Studies at Duke University, [2019] | Series: Documentary arts and culture | Includes bibliographical references and index.
Identifiers: LCCN 2018049444 | ISBN 9781469649665 (cloth : alk. paper) | ISBN 9781469669366 (pbk : alk. paper) | ISBN 9781469649672 (ebook)
Subjects: LCSH: United States—History—21st century—Pictorial works. | United States—History—21st century. | Documentary photography—United States. | Street photography—United States. | Obama, Barack. | LCGFT: Illustrated works.
Classification: LCC E907 .J33 2019 | DDC 973.9320022/2—dc23
LC record available at https://lccn.loc.gov/2018049444

To Daphne

Meditation (noun):

a discourse intended to express

its author's reflections or to guide

others in contemplation.

— Merriam-Webster's Collegiate Dictionary

Contents

THE HISTORIAN'S EYE

Introduction

WHAT THE CAMERA TEACHES

American culture tends not to cultivate or place much value on serious historical reflection. Every now and then, we share a collective reverie along the lines of Errol Morris's *Fog of War* or Ava DuVernay's epic civil rights film, *Selma*; but as a nation our historical attentions more often run in the registers of *Gone with the Wind*, *Davy Crockett*, *Hogan's Heroes*, *The Godfather*, *Jersey Boys*, or *Django Unchained*—not exactly sustained reflection of the sort that enhances historical understanding or roots the present meaningfully in the soil of the past. We have developed a mild taste for history as adventure, as romance, as tragedy, as nostalgia, as escapism, as farce, even as nonsense. But history as an instrument for analyzing the contours and meaning of present conditions, not really, not even in the context of policy debates or political oratory. The culture has a woefully short memory to begin with; but as the basic unit of public discourse has contracted—first to the tiny morsel of the television sound bite, later codified by Twitter at one hundred forty characters—meaningful historical reflection has become an extravagance, and the nation goes careening ever onward.

Which is why the historian in me was so captivated during that first season of Obama, as it were, between the Democratic primaries of spring 2008 and the inauguration in early 2009. Street-level conversation quickly and pointedly fixed on "this historic event" or "this historical

moment," and I heard people all around me — students, colleagues, delivery people, waitresses, barbers, garage attendants — actively placing themselves in the timelines of history in phrases like "I never thought this could happen in my lifetime," or "we're making history," marveling aloud that "this" had not seemed possible in America at all, not thirty years ago, not twenty, not one year ago.

Even the horrors of 9/11 had failed to elicit this widely shared tendency among Americans to suddenly see themselves *in* history. The terrorist attacks may have bifurcated history into a "before" and an "after" for many; there was a lot of talk about how "the world has been changed forever." But this was a fundamentally *ahistorical* conversation underneath it all, in that it rarely demonstrated a true engagement with the details, movements, trajectories, or tendencies of postwar history. In my experience (I was living in Manhattan at the time), most people commented on how the world had been "changed forever" without indicating any idea of a relevant past. For most, the event came out of nowhere. This is hardly a historian's careful formulation. Nine/eleven might prove a "cause" of whatever was to come next, but it absolutely defied definition as a "consequence" of anything that had come before, in popular understanding. The Islamophobic slogan "Everything I need to know about Islam I learned on 9/11" tacitly im-

plied the twinned assertion "Everything I need to know about 9/11 I can *locate* in Islam." The thinking after that tragedy was addled, perhaps understandably so. But it represented above all a widely held and massive ahistoricism, whatever else you want to say about this dreadful collective experience.

But the Obama election was different. People I talked to now saw themselves in history; they actively took measure of the distance back to the Civil Rights and Voting Rights Acts; they paced off and recharted the topography of the post–civil rights decades. "Underneath the river, the river*bed* is moving," artist and photographer Renee Athay said. People now plumbed those rushing historical waters, trying to comprehend whatever subterranean motion it had been that delivered up a Barack Obama after decades that had seemed so stagnant on questions of race and social justice. From Nixon's "southern strategy" to Ronald Reagan's cynical visit to Philadelphia, Mississippi; to the assault on affirmative action; to the rise of the carceral state; to the Rodney King beating and other racialized police violence; to continued and worsening suppression of the black vote; to — *the election of Barack Obama*? The smiles and the awed clicks of the tongue, *Never thought I'd see this day*, represented a vernacular American meditation on the movements of history unlike any I had heard before. On another track,

people in coffee shops or at the local bar were also measuring the economic crisis against the Great Depression and calling for the return of FDR.

Paula Rabinowitz has defined "the status, meaning, interpretation, and perhaps even control of history and its narratives" as what is at stake in most progressive documentary work.[1] The stakes in this particular project were somewhat different—to coax some workable historical thinking as a start; not so much to wrest control of a narrative, but to help in breaking silence and in generating some narratives to work with.

The Historian's Eye began with these observations on the moment, and on the keen public consciousness of the moment, and with a desire to capture it all in a bottle in a one-off documentary on the inauguration. The moment stirred in me precisely that impulse that Robert Coles has described, "to seek to know in such a way that the telling . . . connects others to an observed situation. It is the impulse to reconnoiter, to scout successfully, and to report back . . . about what has been spotted or surveyed."[2] Fieldwork began with revelry in Harlem and then Washington, D.C., on inauguration eve, and the hushed, reverential atmosphere of the National Mall as Obama took the oath of office the next morning. More "church" than "fête," the first inauguration was an intimate gathering of nearly two million jubilant but contemplative on-lookers who had made the pilgrimage from across the country the day before—Martin Luther King Jr. Day, as it happened—to bear witness. The work expanded from there. As the figure of an African American president came over the horizon and assumed the Oval Office in 2009, the omnipresent Shepard Fairey iconography of "Hope" and "Change" tacitly expressed a proposition that found immediate favor in some quarters and struck deep fear in others: that maybe, just maybe, we were not the nation we had always thought ourselves to be. Historic indeed.

These years have never ceased to seem "historic," nor has the sense of their singularity yet waned. Election season in 2008 gave way to the Great Recession and its concerns, as colossal financial institutions were shaken to the core, and foreclosures, business failures, and layoffs swept the country. The political parties became locked in a death grip over budget deficits, stimulus bills, austerity measures, and health-care reforms, questions that pointed toward unbridgeable philosophical differences and to a re-litigation of governing premises stretching back through Reaganomics and the Great Society, all the way to the New Deal. Emergent, innovative forms of political organizing took shape—the Tea Party on the right and the Occupy movement on the left—as did unprecedented challenges to the president's legitimacy: communist, socialist, Kenyan foreign na-

tional, secret Muslim, illegal immigrant, Manchurian candidate, usurper. Historic battles waged in the courts and in state houses over gay marriage, voting rights, corporate power, reproductive rights, and environmental protections at once expressed and created divides in the electorate and deepened pervasive anxieties that the soul of the nation and futurity itself were hanging in the balance.

"A camera," Dorothea Lange once said, "is a tool for learning how to see without a camera."[3] A camera can teach you to see and never to miss the ubiquitous "Space Available" signs that mark hardship and business failures in downtowns and strip malls across the country. These signs stand in for otherwise invisible stories of ruin; they are designed to attract our attention as potential buyers or tenants, but never as the *citizens* of our eviscerated cities and towns. A camera can teach you to see poignant details easily missed, like breakfast dishes expectantly stacked on the counter behind the "For Rent" sign of a recently closed diner, untroubled promises of "guarantee" beyond the overgrowth and chain links of a failed auto shop, competing philosophies of the public sphere embodied by an intrepid soapbox orator and the salaciously clad model pictured on a two-story jumbotron behind him, jostling to overwhelm his Times Square oratory with a sex-inflected commercial appeal of her own. A camera can teach you to read the histo-

ries of rise and fall that are narrated by our cityscapes or to identify the elements of whimsy, humor, joy, grit, determination, and anger that make up a budding social movement.

Moments frozen in photographic time expose a present that only the layers of history could have created. Images of a muscle car in an abandoned lot, a dark and vacant shopping center, or a shuttered New Jersey factory each trace the arc from twentieth-century prosperity to twenty-first-century despair. The plaintive placard at a political rally, "Do I look illegal?," protests Arizona's passage of the law that became known as SB 1070, the "papers please" law, but so does it invoke the deeper legislative history that created "illegal" persons in the first place, and the centuries-long racial history that conjoins the full rights of citizenship with how one "looks." A sardonic Florida marquee, "Be thankful we're not getting all the government we're paying for," perches a Tea Party taxation lament atop the vintage Reagan-era contention that government is the problem, not the solution. A folk guitarist at the head of a throng of Occupy marchers conjures Phil Ochs's 1960s just as surely as he does Woody Guthrie's 1930s.

The images of *The Historian's Eye* provide a documentary archive of the Obama years and their extraordinary, peculiar tensions—a coin toss that has landed on edge. But they also constitute an invita-

tion to reflect, and a prod toward a kind of visual pedagogy—a different way of seeing the past in the present and of seeing the present itself as history in the making. The question at heart of the project is: *What does this historical moment look like where you live?*

The images in this book were taken across the country from 2009 to 2014. Drawn from nearly 4,000 images now archived on the Historian's Eye website (www.historianseye.org), these materials convey the harsh realities of American life during the Great Recession, but so do they capture diverse passions and expressions of civic engagement that are emblems of aspiration, expectation, and promise. Myriad closed businesses and abandoned storefronts stand as a public monument to widespread distress; omnipresent, expectant Obama iconography articulates a wish for new national narratives; flamboyant street theater and wry signage and graffiti bespeak a common impulse to talk back. Together these images reflect the sober grace of a time that is perilous, but in which "hope" has not ceased to hold meaning.

This book is meant to be read in any way you like: there is a legible narrative arc across the volume, were you to read it from front to back. But each pairing of image and text is also a freestanding piece in its own right, a meditation. The major threads that run through and unite the essays include an analysis of the American present

and the past that produced it; reflections on photography as a practice in pursuit of history, and on the relationship between documentary work and scholarly work; meditations on reading images—what the photograph reveals and conceals; and finally, the story of my American Studies road trip across twenty-five states.

To begin, then, four introductory images and notes that lay out some thematic and interpretive building blocks for the interdisciplinary investigation that follows: a note on the ways of seeing that the camera teaches; a note on the nature of the American present, its raw anxiety and twinned feelings of hope and despair; a note on the interpretive method of excavating the past as it shows itself in a photograph's present; and a note on the mutual engagement here between the photographic print and the historical imagination. Photographer Joe McNally once said the best photographer isn't necessarily the one who knows the most about things like lighting and composition; the best photographer is the one who gets the shot. The most I claim as a photographer is that I was able to put myself out there—from inauguration day to the BP oil spill to Occupy Wall Street to Pamela Geller's Islamophobic rallies—to try for the shot. My hope is that this collection might advance a pedagogy of its own, deriving from my own sharp learning curve under the tutelage of the camera.

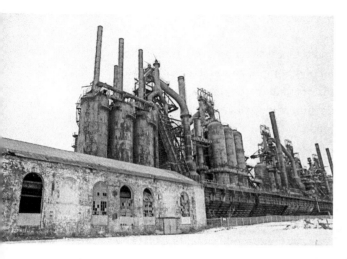

BETHLEHEM, PENNSYLVANIA, 2010

Past and present. The Sands Corporation bought up the old Bethlehem Steel site, at one time the largest industrial brownfield in North America, and is busily converting it into a tourist destination and casino. The same forces that shuttered American steel production in the latter twentieth century created both a service economy and a casino mentality to take its place; for the time being, the Sands in Bethlehem will be our greatest monument to *that*.[4] But the remaining vestiges of "the Steel" (as the workers always called it and still do) are about as close as American civilization will get to the Roman Colosseum, when it comes to the sheer, poignant magnificence of an architectural ruin. When you stand at the base of the mammoth and impressively silent furnaces, when you peer through the fence at stone husks of buildings so massive you could fit football fields inside them, you viscerally feel the passing of a whole way of life. It is as if the wind still carries the blast of the machinery, the report of the factory whistle, the voices and the dogged footsteps of the many thousands who walked through the gates with each changing of shifts.

The past is what the present is made of. I had been teaching history for twenty years before I fully grasped the truth of this. Our restless, impatient, amnesia-addled culture encourages us to think that history is something that has been left irretrievably *behind*, at varying degrees of distance, depending on the number of years gone by. It wasn't until I was exploring the abandoned mill grounds in Bethlehem with my Nikon D70 one howling winter afternoon that I began to see the presence of the past in a new way, in layers, like geological formations that were nowhere behind me, but *beneath and around* me, fully constituting the space that I inhabited. At this site I could not help but register the twenty-five-year geohistorical layer of economic distress embodied in the towering, silent, steel furnaces. A short walk away— no more than a few hundred yards—lay the solemn streets of downtown Bethlehem, whose "auction," "foreclosure," and ubiquitous "space available" signs marked the shallower stratum of historical distress brought on by the crash of 2008. In that particular space on that gusty day, camera in hand and with many hours to meditate in silence, I recognized not only that the past is what the present is made of, but that *the present isn't made of a single other thing.*

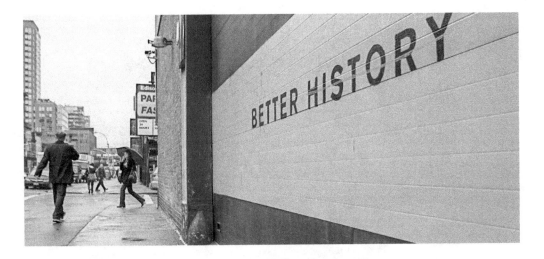

NEW YORK, NEW YORK, 2009

U.S. on edge. "The time has come to re-affirm our enduring spirit," President Obama said in his first inaugural address, "to choose our better history, to carry forward that precious gift, that noble idea, passed on from generation to generation: the God-given promise that all are equal, all are free, and all deserve a chance to pursue their full measure of happiness." This piece of stenciled graffiti on Tenth Avenue in Manhattan honored the president, but perhaps also pled for noble ideas and futurity. Barely legible here is the work of a second graffiti artist, apparently armed with a silver Sharpie, who lightly altered "better history" to read "bitter future."

Among the more poignant aspects of our recent, shared experience has been the uncanny feeling—registered across the political spectrum—that the nation sits at a crossroads, ready at any moment to deliver up its very best or its very worst: the can-do spirit of recovery versus deepening economic crisis; the triumph of racial liberalism versus renewed threats to the Voting Rights Act and direct challenges to our black president's legitimacy; historically unprecedented immigrants' rights rallies versus newly crafted legal hazards and record levels of deportation; the electoral repudiation of war-without-end versus continuing deployments, escalating drone strikes, and widening surveillance practices. Even amid resonant calls to "Hope," the bitter polarizations of our politics have played out against a backdrop of privation and austerity whose crumbling infrastructure and withered sense of the commonweal seems everywhere to announce the end of the American Empire, if not the End of Days. Of course, one person's hope is another's despair. Job creators, or oligarchs? Robust safety net, or creeping government takeover? Responsible austerity, or life-bleeding draconianism? Noble return to the framers' principles, or reactionary bullying dressed up in a quaint, tri-cornered hat? That sense of doubleness expressed in the contest between "better history" and "bitter future" is an apt epigraph for all of the images and essays that follow.

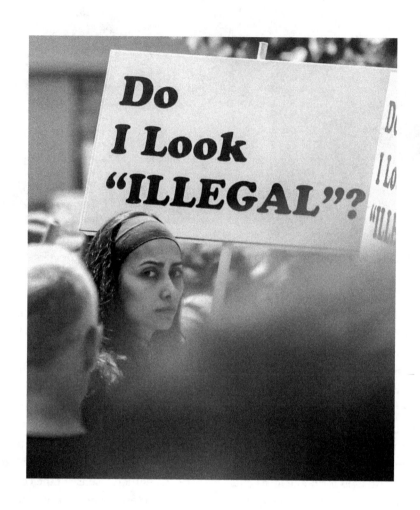

NEW YORK, NEW YORK, 2010

History's depths. The proximate occasion for this immigrants' rights rally and for this placard was the passage of Arizona's SB 1070, the innocuously titled "Support Our Law Enforcement and Safe Neighborhoods Act." The "papers please" law mandated that, during traffic stops and other routine, street-level encounters, local police make an effort to determine the citizenship status in cases of "reasonable suspicion" that the individual might be an undocumented immigrant. Many worried that an entire population — Latino migrants and citizens alike — would be criminalized according to common markers of language, accent, and race. What, after all, would constitute "reasonable suspicion" in the eyes of a Maricopa County sheriff?

The notion of "looking illegal" is rooted in the deep history of immigration law and the juridical structures of U.S. citizenship. The category of "illegal aliens" as we know it today was created by border-crossing protocols introduced in 1907 and by quotas imposed in immigration law in 1924. Those polemicists who tell you that their Jewish or Italian or Greek or Polish grandparents came here legally should also know that the prospects of being deemed *illegal* were completely different — and much narrower — before 1924. Speaking for my own refugee grandfather from czarist Russia, he probably would have come illegally if that had been his only choice. But the *looking* in "looking illegal" dates all the way back to the nation's very first naturaliza-tion law in 1790, whose specification that only "free white persons" were eligible for naturalization embodied the founders' Enlightenment assumptions about "fitness for self-government" and wedded citizenship to whiteness in ways that continue to exert influence at the depths of our public discourse, even after centuries of social change and struggle have transformed our surface conceptions of "we the people." "Do I look illegal?" speaks to the exclusions of 1790 just as surely as it protests the endangerments of 2010.[5]

NEW YORK, NEW YORK, 2010

Photography as historiography. In vernacular discussion, the Great Depression quickly became the most common referent or analogy for our national experience in 2008 and after. How low could we go, first of all? Would this cataclysm reach Depression-era levels of unemployment, business and bank failures, foreclosures, suicides? And what of the response — would Obama prove another FDR? As I embarked on the project, my own practices also looked back to this era. I cannot claim their mantel, but Dorothea Lange and Studs Terkel are undoubtedly the ghosts who informed and haunted my work as I went forward.

But the decision to shoot in black and white was only partly in homage to the documentary photographers of the 1930s. It is a decision that has been questioned whenever I've presented this work in lectures or conferences. "Color is *data*," one colleague objected, "How can a historian choose to diminish his *data*?" My own thinking on this question is twofold. First, we are so surrounded and bombarded by photographic images in the twenty-first century (250 million images are uploaded to Facebook every day — not to mention the rest of the internet, magazines, newspapers, billboards, and the ads splashed across buses and taxis) — to the extent that simply arresting a viewer's attention presents a different order of problem than anything faced by Lange or Walker Evans.[6] In our own world, the black-and-white image steps away from the multitude of color photographs, at once announcing a different intention and requesting a different kind of consideration. *The Historian's Eye* is a contemplative project, and grayscale, I contend, invites a different level of contemplation. And second, since we are used to seeing historical photographs in black and white, the grayscale also tends to engage the historical imagination more readily than full color. This historicization of the present and very recent past — at once conceptual and visual — is at the heart of the project, and the formal elements of the images are meant to serve it.

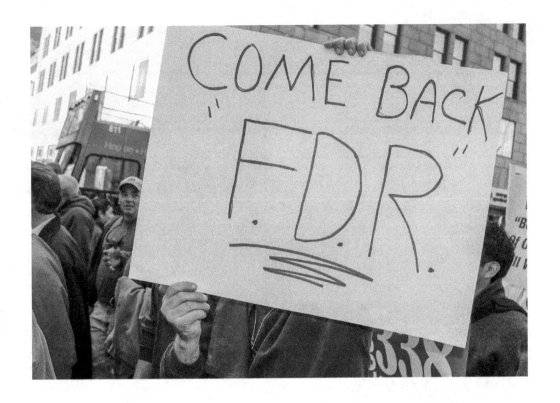

1

Barack Obama, the Icon

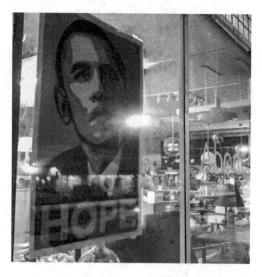

CAMBRIDGE, MASSACHUSETTS, 2011
Soon after the first Obama inauguration, conservative commentators like Sean Hannity and Glenn Beck began to protest the very un-American "cult of personality" that had developed around the new president. While it is true that Obama quickly generated a richer iconography than perhaps any other sitting president, it hardly represents a cult of personality *per se*. This truth became clearer over time, as disappointment with Obama grew notably among progressives, even while ubiquitous images of the president—in places both public and private—continued to multiply. Obama's iconic image (like his 2008 slogan, "Yes We Can!") did a great deal of ideological work for a nation whose history is steeped in white supremacy but whose post–civil rights ethos gave voice to hopeful resistance and alternatives.

Having served as president of the *Har-vard Law Review* in the 1990s, a younger Barack Obama noted that interest in his life story in *Dreams from My Father* testified to "America's hunger for any optimistic sign from the racial front—a morsel of proof that, after all, some progress has been made."[1] His ascendance to *the* presidency in 2009 became the greatest morsel ever—more than a morsel. The relationship between Obama and the civil rights legacy remains unsettled: as artist Ricardo Levins Morales soberly points out, it takes a revolutionary visionary to push doors open, but those who walk through them—like Obama—are not likely to be revolutionary visionaries themselves.[2] And yet in myriad Shepard Fairey "Hope" and "Change" posters lovingly hung in restaurants, bars, and private living rooms across the country; in kitsch items sold as souvenirs; in "Obama 44" Major League Baseball team jerseys; in stage plays like *That Hopey Changey Thing* (New York) or *Barackalypse Now!* (Chicago), the omnipresent figure of Obama, deployed in unexpected places and in a thousand different moods, embodied a public contest over precisely what the "post" of "post–civil rights" might mean, and articulated a widespread yearning to tell a different story about who we might yet turn out to be as a nation.

WASHINGTON, D.C., 2013

The second Obama inauguration felt like a party. The ubiquitous American flags represented a gleeful piece of reappropriation, after generations of public discourse had seemed to sequester the nation's patriotic symbology on behalf of the Right alone. Like the Obama presidency itself, too, all this exuberant flag-waving put an exclamation point on the disarticulation, once and for all, of "American-ness" from *whiteness.*

The first inauguration, on the other hand, had felt more like a church service. Even amid the jubilant gathering of 1.8 million people, there was a hush and a reverence for the moment that was unlike anything I have experienced anywhere else. We walked to the National Mall from a friend's house in Arlington, Virginia, starting at about 4:00 A.M. Even at that hour, shadowy clusters of humanity were drifting in the streets through the darkness toward the mall with us. At first I associated the quiet with the hour. But that peculiar stillness actually characterized the entire day—the most striking thing about that event was not the spectacle, not the scale of this biggest inauguration crowd ever, but the calm and the look of genuine awe and veneration on every individual face. Some version of *Never thought I'd see this day* was in the eyes of everyone in the multitude—especially but not exclusively the African Americans of a certain age—and also a joyous and unbelieving *Isn't it magnificent?* As Obama called on us from the dais "to choose our better history," what was pal-

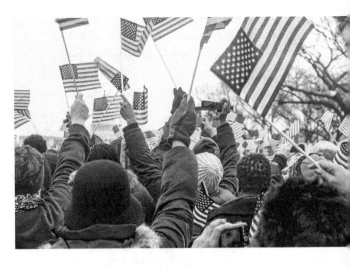

pable in the air was a collective sense that *this*—not the Emancipation Proclamation, not Juneteenth, not Jubilee celebrations, not the '64 Civil Rights Act—but *this* at last marked the coming of African Americans' full citizenship. The vast distance between the pious contemplation of the first inauguration and the rowdy flag-waving of the second measured the extent to which the blackness of the president had been successfully digested and metabolized in the political culture in four short years. A "post-racial" nation, as some wish to suggest? Absolutely and quite obviously not. But over that span, a certain cohort of Generation Z did have the chance to come to consciousness thinking that it was perfectly "normal" for a black man to occupy the White House, and this has to change the nation in the long run.

"Barack Obama's black presidency has shocked the symbol system of American politics," wrote Michael Eric Dyson.[3] The concentric circles of this photograph—my rendering of this photographer's rendering of a momentous event that had already been rendered as a souvenir hat—document precisely that shock.

The whiteness of the normative American was written deeply into the nation's political culture from the founding, and nowhere more forcefully than the normative figure of the president. It has been our great fortune that the founding documents were drawn up in universalist language—phrases like "all men are created equal" lent a rhetorical foothold to later comers like Frederick Douglass, Sojourner Truth, and Martin Luther King Jr., even if the three-fifths clause, the 1790 Naturalization Act, or George Washington's efforts to recover his "absconded" slave, Oney Judge, left no doubt as to what the framers actually meant. This was not simply a matter of slavery, but of race more generally: in Euro-American Enlightenment thought, the fledgling democratic experiment depended on conceptions of the citizens' "reason," "rationality," "virtue," and "self-possession," all of which were already *raced* as unique properties of the white European. (A revolutionary-era encyclopedia defined the word "Negro" to include "idleness, treachery, revenge, debauchery, nastiness and intemperance."[4]) Which is why the rights of even *free* blacks were severely curtailed in most regions even before Jim Crow; it is also why white "democrats" could comfortably embrace Indian Removal, Manifest Destiny, Chinese Exclusion, or the abrogation of "inalienable rights" in Hawaii, Cuba, Puerto Rico, and the Philippines. Speaking of the peoples in these new U.S. possessions, Teddy Roosevelt testily swatted down the notion "that any group of pirates and headhunters" could be transformed "into a dark-hued New England town meeting."[5] This is also partly why Reconstruction governments met with such a storm of white terror in the 1870s, and it is probably why the *crushed* experiment of Reconstruction is often remembered as a "failed" experiment. The most extreme anti-Obama backlash, in fact, resembles nothing in U.S. history quite so much as it resembles the white response to "black rule" in the 1870s.

Obama likes to narrate his biography as a tale of American exceptionalism and extraordinary "opportunity"—only in America could his story become true. But Obama's foes and his admirers alike seemed to acknowledge that his ascendance to the presidency ran right to the core traditions and mythologies of *white rule*. It does not merely shock the symbol system. In a just world it would shatter it.

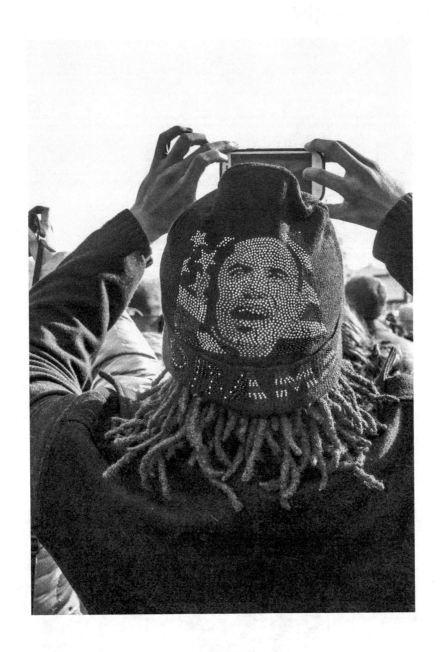

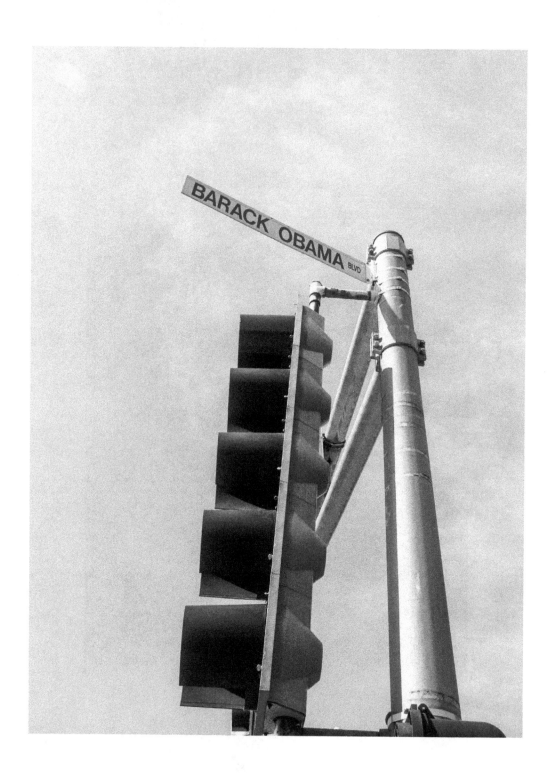

SAINT LOUIS, MISSOURI, 2009

According to Wikipedia, as of 2018 the list of things named after Barack Obama since 2008 includes schools in ten states, streets in four states plus Tanzania, and a mountain in Antigua and Barbuda. It also includes several species appellations in the scientific world: the *Obamadon* (an extinct lizard), the *Aptostichus barackobamai* (a species of water trapdoor spider), and *Paragordius obamai* (a parasitic worm — evidently named by a Republican).[6]

Delmar Boulevard in Saint Louis was renamed for Obama in 2008. It reflected the widespread desire to mark the moment of the black president's ascension, even before it was known what kind of president he would turn out to be. This suggests a certain eagerness for national revisionism — the rush was not so much to honor *him*, but to honor *us* and to tell a new story about who we are as a post-racial electorate. But the renaming in Saint Louis did not go off without some controversy. Delmar Boulevard was a major east-west artery that had become known as a significant racial dividing line bisecting the city. Many felt that a Barack Obama Boulevard ought to be a north-south artery that did not divide the city's largely segregated neighborhoods, but connected them. But there were also many in Saint Louis who objected to honoring the newly elected president at all. Alderman Kacie Starr Triplett wrote that she was "completely surprised by the amount of opposition and hate mail recv'd for the proposed honorary name change. . . . It did successfully pass, but not without a fight."[7]

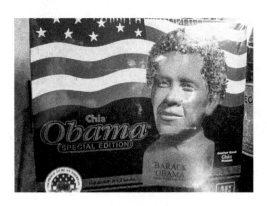

NEW YORK, NEW YORK, 2009

In 1977 Joseph Enterprises introduced the Chia Pet, a terracotta statuette that held water like a vessel but whose porous ceramic surface could host live chia sprouts that looked like fur or hair within ten days or so of germination. The original Chia Pet was a ram, and the first several iterations through the 1980s stuck closely to the natural world—bulls, puppies, kittens, trees. The list of Chia products later expanded to include familiar figures from popular culture like Elmer Fudd, Bugs Bunny, Scooby-Doo, Bart Simpson, or SpongeBob. The Chia Obama (released in 2009 in two attitudes: "happy" and "determined") represented Joseph Enterprises' first foray into the realm of historical figures, a project that has since been expanded to include George Washington and Abraham Lincoln on one end of the timeline, and Mitt Romney, Newt Gingrich, Bernie Sanders, Hillary Clinton, and Donald Trump on the other.

The advent of the Chia Obama came amid a wave of giddy Obama depictions across myriad venues and forms, as the culture absorbed the novel fact of an African American president. There were Obama refrigerator magnets, trinkets, action figures, and dolls, including a ukulele-playing dashboard doll; there were scores of Barack Obama coloring and activity books for children; there was an Obama edition of *The Amazing Spiderman* comic book, and Obama made appearances in *MAD Magazine*, *Captain America*, *Archie*, and *Godzilla*; there was a brand of Obama breath mints called Yes We Candy; there were several versions of Barack Around the Clock (a wristwatch, an alarm clock, a wall clock, and a song); and there was the Yes We Cam, an iPhone app that transformed images from one's photo album into Obama-themed "Hope" posters. The Smithsonian sponsored a "Quilts for Obama" exhibit; Lehigh University mounted an Obama folk-art show; and Cornell University developed a digitized web gallery of "President Barack Obama Visual Iconography."[8] *Billboard*, for its part, posts the following top ten list of Obama pop songs: "My President" (Young Jeezy), "Bring It on Home" (Mariah Carey), "Jockin' Jay-Z" (Jay-Z), "Changes" (Common), "Yes We Can" (will.i.am), "Work to Do" (Kidz in the Hall), "Why" (Common, Styles P and Nas), "Letter to Obama" (Joell Ortiz), "Black President" (Nas), and "Keep Moving Forward" (Stevie Wonder).[9] In 2009 I met a young man in Times Square selling "Obama Condoms." And in 2013 Sony Pictures brought us *White House Down*, a black-president-in-peril film in which Jamie Foxx tells us, "I don't wanna make history, I wanna make a difference." In real life, the nation obsessed on the making history part.

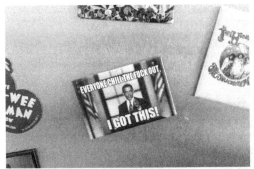
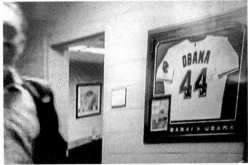

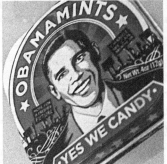

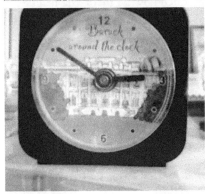

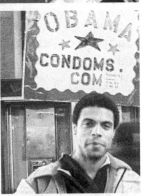
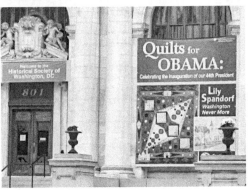

Obama was the first sitting president ever to visit the Baseball Hall of Fame in Cooperstown. After listening to a curator's presentation on Jackie Robinson and the desegregation of baseball, Obama responded, "That's great. Gotta have everybody on the field."[10] The mythos of this moment is chin-deep and very dense: national pastime and American presidency, sacred spaces of baseball diamond and Oval Office, two of the greatest African American "firsts" — speaker and listeners alike must have felt in their very bones the force of the histories being invoked in the phrase *gotta have everybody on the field* in this setting. Nor is the association between the national pastime and civil rights politics a casual one. "You'll never know what you and Jackie and Roy [Campanella] did to make it possible to do *my* job," Martin Luther King Jr. once told Robinson's teammate Don Newcombe.[11] Barack Obama might have said the same. The mechanics of social change are such that no nation could get from Nixon's "southern strategy" in 1968 to Obama's election in 2008 without the work that *culture* does — sports, film, music, TV, the arts. Analyses that seek to explain the unforeseen election of a black president must begin with post–civil rights political history, to be sure — Shirley Chisholm, John Lewis, the Congressional Black Caucus, a generation of black big-city mayors, Jesse Jackson, important African American appointees like Colin Powell and even Condoleezza Rice. But the nation that had changed enough to elect Barack Obama cannot be grasped without recourse to cultural history as well — critical subterranean work had to be accomplished by figures like Prince, Spike Lee, Venus and Serena Williams, Whitney Houston, Michael Jordan, Chris Rock, Denzel Washington, Derek Jeter, Beyoncé.

After the Giants' championship visit to the White House in 2011, relief pitcher Sergio Romo called Obama "a cool cat."[12] Several teams had marked the historic election by marketing "Obama 44" jerseys in 2009, but the Giants' affinity with Obama seemed special. There is an unmatched blue-state culture to the Giants franchise — a certified green stadium, LGBT promotional nights, It Gets Better videos produced by the team, the league's first (and only) African American stadium announcer (Renel Brooks-Moon — the only woman announcer to boot).[13] Romo himself famously wore an "I Only Look Illegal" T-shirt to the World Series parade. Gotta have everybody on the field.

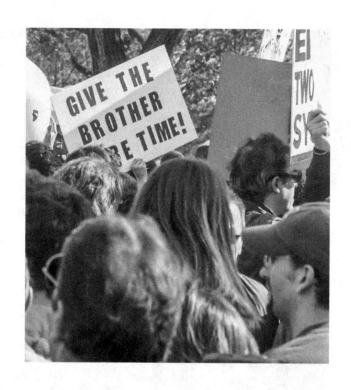

WASHINGTON, D.C., 2010

In response to Fox host Glenn Beck's Restoring Honor rally in Washington, comedians Jon Stewart and Stephen Colbert called for a rally of their own. Beck's event was widely criticized for its slanderous depiction of American patriotism as the religious Right's exclusive property, for its narrow-minded conception of the "real America," and for its cynicism in grasping at the mantel of MLK (the rally marked the anniversary of the March on Washington, and took place on the very spot). The answering Rally to Restore Sanity and/or Fear drew 200,000-plus people for a carnivalesque, hilarious, but trenchant and level day of commentary on the divisive state of American politics. A range of speakers graced the stage, and the headlining comedians conducted themselves as expected; but most memorable was the brilliance of the crowd's own collective determination to deploy humor as a form of serious comment on the polarization, bad faith, and destructiveness of contemporary discourse. Protest signs made impassioned declarations like "It's a Complex Issue" or urged "the separation of head from ass." A few referenced the race of the president— in mock horror: "How did my president get so dark?" I photographed a "reporter" wearing a credible press pass whose Fox News logo bore the legend "We Make Shit Up." Stewart closed the proceedings: "We live now in hard times, not in end times," he said, calling for reason. "We know instinctively as a people that if we are to get through the darkness and back into the light, that we have to work together."[14] Many were disappointed when Stewart later backpedaled from the significance of the event, as the spirit of the day *had* so earnestly embodied a thirst for real change and justice.

"GIVE THE BROTHER MORE TIME!" remains my favorite placard from that day— hopeful about things to come, affectionate in its use of the word *brother*, expressive of a rationality and patience that are withering in our political culture. But crucially, "more time" for the "brother" also evokes the racial disparities in sentencing in American criminal justice. (Obama had signed the Fair Sentencing Act just two months earlier.) The ACLU finds that in Louisiana *90 percent* of the people serving life-without-parole sentences for nonviolent offenses are black. States like Mississippi and South Carolina are close behind, but even in the federal system that figure is 60 percent.[15] The placard distills in five words an eloquent plea for equity—*why do brothers in the system get so much time and the brother in the White House so little?* You know why.[16]

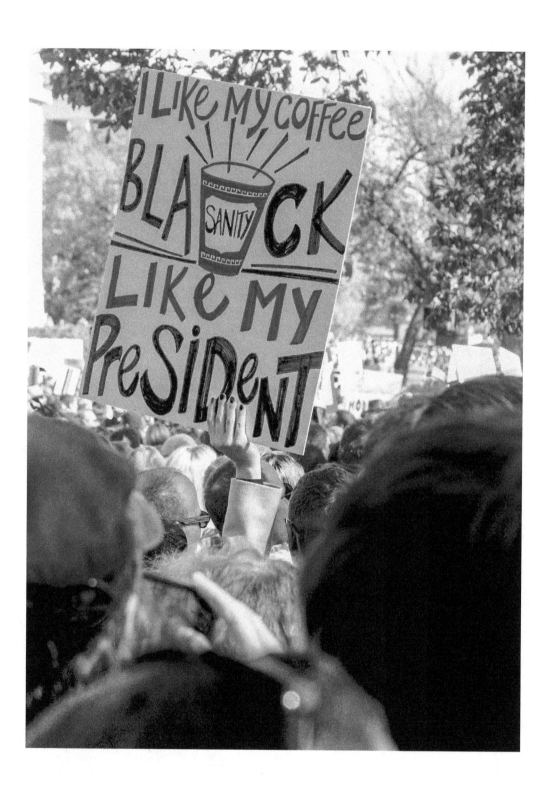

WASHINGTON, D.C., 2010

While the culture at large was prone to obsessing out loud about the president's blackness, Obama himself addressed it relatively infrequently, to the extent that when he did at all, it usually became newsworthy. Examples include his intervention in the Henry Louis Gates/Cambridge Police fiasco, when the Harvard professor was arrested for breaking in to his own house, or Obama's poignant comment that, "If I had a son, he'd look like Trayvon."[17] His most elaborate direct comment on race was his "More Perfect Union" speech in Philadelphia in March 2008 (often simply called "the race speech"), in which he articulated his version of American exceptionalism in purely racial terms:

> I am the son of a black man from Kenya and a white woman from Kansas. I was raised with the help of a white grandfather who survived a Depression to serve in Patton's Army during World War II and a white grandmother who worked on a bomber assembly line at Fort Leavenworth while he was overseas. I've gone to some of the best schools in America and lived in one of the world's poorest nations. I am married to a black American who carries within her the blood of slaves and slave owners—an inheritance we pass on to our two precious daughters. I have brothers, sisters, nieces, nephews, uncles and cousins, of every race and every hue, scattered across three continents, and for as long as I live, I will never forget that in no other country on Earth is my story even possible. It's a story that hasn't made me the most conventional candidate. But it is a story that has seared into my genetic makeup the idea that this nation is more than the sum of its parts—that out of many, we are truly one.[18]

Speaking on comedian Marc Maron's podcast *WTF* in 2015, Obama lit up the Twittersphere when he said, "We are not cured of [racism]. And it's not just a matter of it not being polite to say 'nigger' in public. That's not the measure of whether racism still exists or not."[19] The potential charge of racism, of course, is why his political enemies tended to mention Obama's race even less frequently than he did. Patent references to race (even indirect ones, like Gingrich's "food stamp president") were far, far fewer than coded objections, like Donald Trump's oblique question "Why doesn't he show his birth certificate?"[20] The delicious double entendre of "I like my coffee BLACK like my president" relished the singularity of the historical moment, but also spat back at the white supremacism—however veiled—of many Obama detractors.

OAKLAND, CALIFORNIA, 2010

In restaurants, bars, and other public spaces from Harlem to Tuscaloosa to Minneapolis to Seattle, I saw many warm and adoring portraits of Barack Obama that seemed to me to address something other than a *national* storyline. In these depictions there is an intimacy, a kind of esteem at once familial and proprietary, that manifestly addresses a community of color. Poet Fred Moten, although among Obama's most condemnatory African American critics, best put this quality into words: "I remember when I was in my office the day after he was elected, and of course at Duke [University] the women who clean up the offices are black, and you get to know them and talk to them in the hallway; and they were just—*HAPPY* [laughs]. This woman came past my door, she looked at me and just *smiled*, you know, and put her thumbs up, like there was a secret that wasn't a secret anymore. And I was totally happy that she was happy, and I think I understood some of why she was happy. *I* wasn't happy, but I was happy she was happy." When Moten finds himself confronted with "this nasty crazy shit that [racists] say about Obama," he feels himself pushed into a communal defense. "I don't even feel like I'm defending *him* as much as I'm defending *her*, I'm defending the people who have an investment in him."[21] It is something like this communitarian understanding and investment that I see in images like this one painted on the kitchen wall of a barbecue joint in Oakland.

During the trip when I took this photograph, there was only one African American man whose image you were as likely to encounter as Barack Obama's in the public spaces of Oakland: Oscar Grant. Grant had been shot and killed by a transit police officer while handcuffed and lying on his stomach on the platform at Fruitvale Station on New Year's Day 2009, three weeks before Obama's inauguration. The BART officer, Johannes Mehserle, was convicted of involuntary manslaughter (not second-degree murder or even voluntary manslaughter) in mid-2010, and amid fierce protests, portraits of Oscar Grant went up all over town with rallying cries like "demand justice" and "justice for Oscar." No one knew in 2010 just how many outrages of police violence would pile up in the coming years; and indeed, it was the Oscar Grant killing itself, on a BART platform crowded with vigilant onlookers, that ushered in an era when witnesses' cellphone videos would routinely substantiate the allegations of police misconduct that African Americans had been voicing for decades. But those ubiquitous portraits of Barack Obama and Oscar Grant in 2010 Oakland remain a poignant American diptych, never to be separated. As Fred Moten intuited—"I think I understood some of why she was happy"—on their own, neither the one portrait nor the other can tell us where we are.

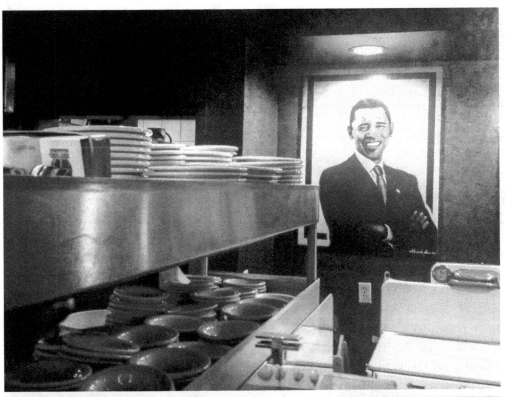

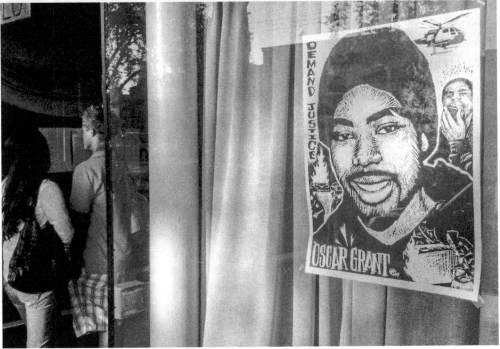

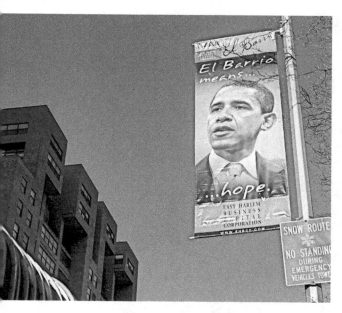

NEW YORK, NEW YORK, 2010

In a setting like East Harlem, "El Barrio means hope" communicated not only an inspiration deriving from Obama's singular life story, but the broader anticipation of a more just civic culture and improved life chances for those who had been marginalized. This latter brand of hope frayed fairly quickly. In early 2010, historian Nikhil Singh reflected on the shifting presidential analogies used to describe Obama. On a downward slide that had started with FDR comparisons, already people were wondering, would Obama end up like Lyndon Johnson, his presidency wrecked by "guns and butter"? — or worse yet, like Jimmy Carter, "a one-term, rather ineffectual, naive, bit of a greenhorn . . . someone who really never . . . got any traction in terms of his policy initiatives."[22] The power and symbolism of the groundswell through the election cycle had caused some to mistake

the Obama phenomenon for a second civil rights movement. Even those who were not bamboozled by improbable talk of a "post-racial" America were nonetheless apt to see his election as representing something more broadly consequential than perhaps it did. But initial euphoria gave way to more sober judgments: the unprecedented, implacable opposition to his every move on Capitol Hill — and indeed, the new president's own predisposition for conciliation and compromise — fairly quickly dispelled the fallacy that a revolution had occurred.

It is fabulously ironic, then, that amid a creeping disillusionment, his administration oversaw one of the most breathtaking periods in progressive history when it came to LGBT rights. In six short years, the United States saw the Matthew Shepard and James Byrd Jr. Hate Crimes Prevention Act (2009); the Don't Ask, Don't Tell Repeal Act (2010); Executive Order 13672, which applied existing antidiscrimination legislation to sexual orientation and gender identity for federal workers and contractors (2014); the extension of the Family and Medical Leave Act of 1993 to include same-sex partners (2015); and *Obergefell v. Hodges*, which rendered state-level bans on same-sex marriage unconstitutional (2015). Towards the end of Obama's presidency, soccer star Abby Wambach remarked, "The whole idea of 'coming out of the closet' is sooo 2010."[23] Maybe *because* of Obama's race, the nation's civil rights achievements during his administration were destined to be greater here than in the anticipated ethno-racial gains of the inner city and *el barrio*.

NEW YORK, NEW YORK, 2012

Republican nominee Donald Trump launched his political career as an out-spoken conspiracy theorist on the question of Barack Obama's citizenship. Of course Trump had already been in the public spotlight for decades—as a real estate tycoon, USFL owner, Miss USA pageant executive, casino owner and hotelier, reality TV star, and—lest we forget—head of an ugly New York lynch mob during the "Central Park Jogger" case in 1989. (Trump placed several full-page ads screaming for the execution of the so-called Central Park Five, who were later exonerated by DNA evidence.[24]) When Trump began exploring a run for president in 2011, his allegation that Obama's supposed Kenyan birth made him an illegitimate "usurper" became a staple of the mogul's public commentary. Trump claimed to have dispatched a team of investigators to Hawaii, whose findings would expose "one of the greatest cons in the history of politics and beyond."[25] He hammered on this theme long after the White House had taken the extraordinary measure of publishing Obama's long-form birth certificate from Hawaii Maternity and Gynecological Hospital.

Unable to quell Trump's allegations through the normal means of reason, evidence, and argument, the White House shifted tactics. "There's really no way to make the conspiracy about Obama's birth certificate completely go away," read a message on his campaign website, "so we might as well laugh at it—and make sure as many people as possible are in on the joke."[26] This "Made in America" mug (fea-

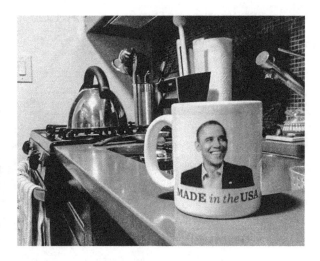

turing an image of Obama on one side and his birth certificate on the other) was one result. Obama seemed to take a particular relish in his barbed, anti-birther jokes. "This all dates back to when [Trump and I] were growing up together in Kenya," he quipped on the *Tonight Show*. "We had constant run-ins on the soccer field, you know he wasn't very good and resented it. When we finally moved to America, I thought it would be over."[27] At the Washington Correspondents' Dinner in 2011 he announced, "Tonight, for the first time, I'm releasing my official birth *video*." He then rolled a clip of the African birth ceremony from Disney's *Lion King*, while "The Circle of Life" blared. "Oh well, back to square one," the president shrugged.[28] By 2016, according to the most consequential polling data we have, about 50 percent of Americans were in on the joke.

NEW ORLEANS, LOUISIANA, 2010

Among the few decorative accents in this Seventh Ward home — the Saints flag, a resplendent feathered Mardi Gras umbrella on the floor just outside the frame — was this photoshopped picture of the homeowner standing between MLK and Barack Obama. Stories like Paul Landry's were common enough in New Orleans, but remain mostly unknown to those with no connection to the city. He and his wife had fled as Katrina's waters rose; he returned to find the watermark in his living room at about eight feet.[29] Five years on, Paul's wife was still in "Katrina exile" in Fort Worth, and he was still rebuilding their house in his free hours, one board at a time, with a paltry Road Home grant that had been slashed by some bureaucrat in Baton Rouge on the lookout for anything smacking of illegal home improvements — such as rebuilding things to code that had been below code in the original.

When I asked Paul about Obama, he answered with a stirring intimacy and pride. "[I'm] congratulating him for being the first black president," he said. "He's in that and he talk real good, he's saying real things, and he's trying to do real things. . . . He ain't been, a year or something now? . . . And where he's working, I'm saying to myself to him, OK, you're doing good with that, Barack. . . . Now if you could start getting this job thing going, people start going back to work, bring that deficit down. . . . It's going to be marvelous. Man will go down in history. And I think that's a good thing. Thank God, he must be a God-sent man." Gesturing to the photograph, Paul then broached a subject that many had surely suffered in silence ever since the inauguration, when the Obamas left the presidential limo to walk openly among the people on Pennsylvania Avenue: "I hope Barack be all right and nobody going to try to kill him or something like that. God knows if something happens, I don't know what his brothers might do behind that." For all of the endless commentary on Obama over the course of his presidency, I don't know that I've ever heard anyone remark on how *brave* he has to be.

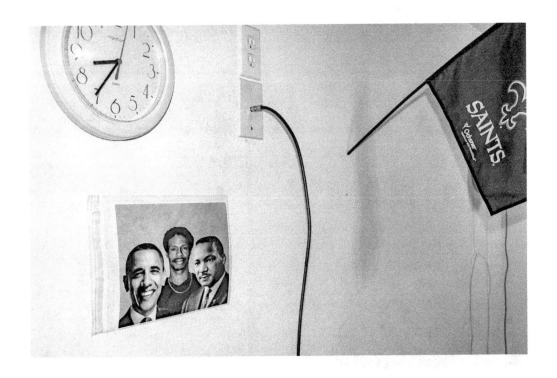

GAINESVILLE, FLORIDA, 2009

This cardboard cutout of Obama was standing in the Alachua County (Florida) Democratic Party headquarters about a year after the election. While this may have been just another piece of party ephemera sent from the DNC, its placement seemed to express a certain pride in what Obama's image said about the Democratic "brand." The party chairman for the county was a transplanted New Yorker, whose every comment about Florida politics communicated, *I like it here, actually.* He spoke with exquisite subtlety about the changing political dynamics of the state—an increasingly active African American community; a generational shift within the ultra-conservative Cuban community; a sizable influx of non-Cuban Latino/a migrants; a Republican Party culture firmly rooted in Nixon's "southern strategy," but also a distinct population of "old" (white) Democrats, vestigial remnants of the "solid" South. "In some of the rural counties . . . they haven't entered the twentieth century," he said, "let alone the twenty-first." But he also showed a visible local pride in Obama's margin in Alachua County (11 percent in a state that gave Obama a bare 2 percent margin). "There are people who'd never vote for a black man, but [Alachua] is a funny county," he told me. "I think we're reasonably tolerant in racial ways." This plainly gave him great satisfaction.

But "change is a tricky thing, and people get nervous," even the sanguine party chairman had to admit. While he described the political map of Alachua as "kind of a pink donut around a blue city," volunteers from this office had encountered plenty of deep red, even in Gainesville. One described the "older white women" she met while canvassing, who "just didn't think they could vote for [Obama]. And when I tried to talk about issues, they would get sometimes agitated, like, you know, 'I just can't talk about it.'" She was most surprised by younger people around the University of Florida. "Assault weapons were a big deal," she reported with wonder. "You would not believe how many nineteen-year-old men who are students at UF, the first thing they say is, 'He's going to take away my assault weapon.' I said, 'Oh, you have an assault weapon?' And they're like, 'Well no, but if I ever need one . . .'"[30]

While in Gainesville I learned that there *had* been enormous rushes on guns and ammo at local gun dealers ever since the election. Ammunition at the local Walmart was flying off the shelves so fast that its scarcity "proved" to some that Obama was "taking away our guns." "In 2009, everything was selling," one gun dealer later told the *Gainesville Sun*, ominously adding, "The only thing that wasn't selling were hunting rifles." After Obama's reelection in 2012, the *Sun* reported that once again, "Obama re-election a boon for gun dealers." Over 3,000 people in Florida submitted requests to purchase firearms on the *single day* after his reelection, even though his first term had seen no significant change in gun laws.[31] So Obama may have attained a surprising level of acceptance and even adoration in Alachua County, but yes, "change is a tricky thing, and people get nervous."

Two stories, one of them true and the other one factual. This Obama poster ("We Made History") hung in the stairway of a suburban home owned by an African American woman whose family history runs from slavery through the Jim Crow South, and from there—via the Great Migration and two generations of education and professional achievement—to suburban New Jersey. In this lighting and from this particular angle, the poster does not seem to be *placed* so much as *enshrined*. The patterns of shadow and luminosity, and the upward gaze from somewhere beneath, communicate aspiration, mobility, and triumph in much the same fashion as some Migration-era canvasses by painters like Aaron Douglas and Jacob Lawrence. A new chapter in black freedom, the poster says. Bursting into the light from a dark saga of striving amid only imperfect emancipation, the photograph says.

Now, the factual story. The poster had been gifted to the homeowner by a white colleague, who wanted to mark the moment and to engage with her black friend in the joyous collective accomplishment of the Obama election. The African American homeowner had grown wary of the "we" in "We Made History." While it was undoubtedly true that the interracial coalition of voters who installed Obama in the White House was historically significant and something to celebrate, still, she had to wonder, was this interracial "we" a sly displacement of the *blackness* of the event—

an implicit bid for white ownership of the Obama moment, like the "we" of rock and roll, for instance, or come to think of it, the "we" of southern planting and of northern abolitionism? But she wanted to put the poster up in consideration of her white friend. And so she compromised. She hung it out of the way, in a stairwell.

Perhaps both stories tell us something worth knowing.

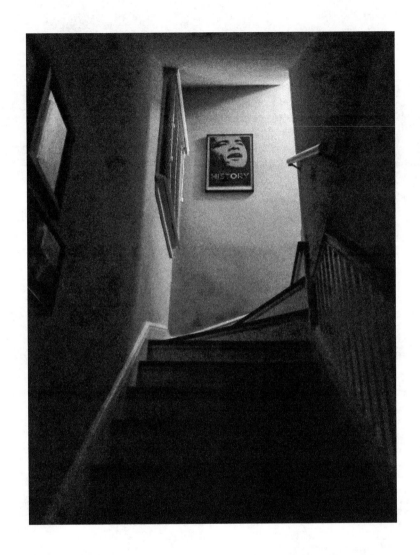

2

At the
Crossroads
of Hope and
Despair

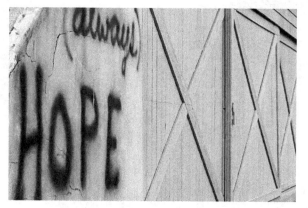

PRINCETON, NEW JERSEY, 2009

"Hope's thin, despair is thick," writes novelist Viet Thanh Nguyen.[1] Anyone who has spent much time in either state recognizes the truth of this. But for a brief time in 2009, hope was thick. The word was everywhere, and each usage tacitly footnoted Barack Obama and the idea that fortunes can change—not least of all, national fortunes. It felt good while it lasted, but this hope did thin out over time. Soon enough Sarah Palin would be drenching the word in a brand of sarcasm that only she could muster (and that only comedian Tina Fey could fully command): "How's that hopey changey thing workin' out for ya?" It's a mean, mean politics that disparages *hope*; but maybe forward-looking expressions of hope just bespeak the despair of the moment anyway.

This message, splashed across the concrete abutment of an equipment shed at the edge of Lake Carnegie, was notable for its incongruence with the setting. As a piece of graffiti, it was strange: it was in a secluded, rural setting; it faced the lake, not the road—it was weirdly private. In order to read it, one had to already be standing in a wooded, lakefront spot so peaceful and splendid that enunciations of "hope" seemed only to restate the obvious. Amid such beauty, who needs a caption like this? Maybe it was meant to cheer on the scullers practicing daily on the lake. But there is a lot of graffiti along this corridor—Routes 27 and US 1 through central New Jersey—much of it more despairing and harsh than this. It's hard not to read this as part of that conversation. (Not so far from here, for instance, someone had scrawled "FUCK THE POLICE" in giant black letters across the wall of a closed Saab dealership.) I find myself wondering about the mood and the spirit of the person who paints "(always) Hope" in a spot like this—how thick or thin their own hope was running.

READING, PENNSYLVANIA, 2010

Beginning with Lehman Brothers' bankruptcy in September 2008, the United States went into a dramatic economic tailspin whose rapidity was unforeseen and whose devastation remained unimaginable to many, even after it had hit. Pacifica Radio had reported on the coming subprime mortgage crisis years before and had predicted a "Great Depression-like" catastrophe; but Pacifica's was pretty much a lone voice. With dizzying speed and still wholly unexpected by most, in late 2008 huge financial institutions went into crisis, businesses of all sizes closed down, consumer spending plummeted, unemployment and foreclosure figures shot up, and decades of economic growth and personal savings evaporated. More than two and a half million jobs were lost in 2008. Though not of Obama's making, the recession defined his presidency, as it has American life in general in the years since.

"September 15, 2008, the date that Lehman Brothers collapsed," writes economist Joseph Stiglitz, "may be to market fundamentalism (the notion that unfettered markets, all by themselves, can ensure economic prosperity and growth) what the fall of the Berlin Wall was to communism." This kind of epochal interpretation—Stiglitz's idea that the period from the fall of the Wall in 1989 to the crash in 2008 represents a brief "period of American triumphalism" that has now decisively ended—is useful in thinking about the contours of the Obama years.[2] On top of

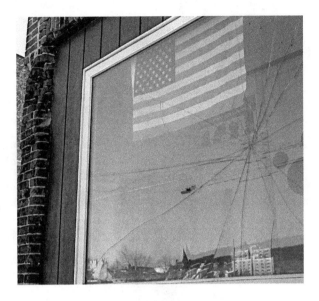

the colossal economic crisis itself, on top of the decades-long polarizations of our red state–blue state politics, on top of whatever racial burdens the president was made to carry in a country where the normative citizen—and certainly the normative leader—was *white*, Obama was also contending with the inarticulate but powerful and widespread national malaise that settled over the land as American triumphalism came crashing down. He managed to beat it back in 2012, but the rise of Trump in 2016 finally gave full voice to its fury.

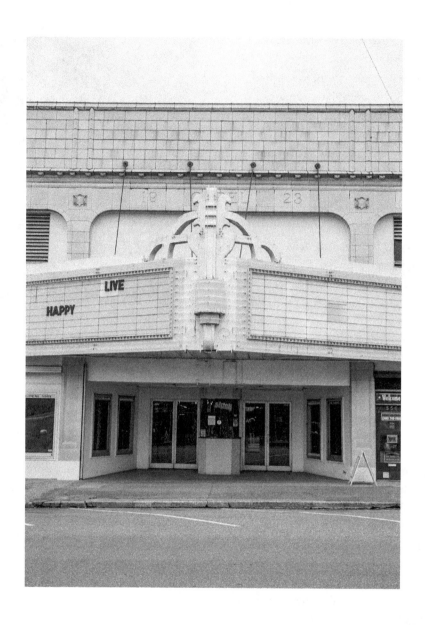

CHEHALIS, WASHINGTON, 2010

Along with the landmarks of collective sadness, one finds endless, sardonic commentary in the nation's public spaces. The proud, 1923 vintage Beaux Arts architecture tells one story; its desertion, another; and the cunning captioning—acerbic? buoyant?—yet another. This theater closed down early on in the recession, in December 2008.[3] The spacing of the words on the marquee suggests not a written message so much as a kind of found poetry, an impish work of erasure. One imagines the original announcements that the recession might have frozen in eternity, like the time-suspended marquee I saw at a shuttered New Orleans school that to this day anticipates the students' return for the fall of 2005. "STAYING ALIVE / HAPPY GILMORE." "FOGHAT LIVE / HAPPY THE MAN." "POPEYE & OLIVE OYL / IN 'HAPPY BIRTHDAZE.'" Or—after all, it is a small town—"YOU GO MARGE & CLIVE / HAPPY ANNIVERSARY." The anonymous poet's work was keen. Whether an earnest piece of advice or a dare to just go ahead and try, "Live Happy" spoke poignantly to the ghostly post-crash scene on North Market Boulevard in Chehalis.

ALLSTON, MASSACHUSETTS, 2010

At one point in Richard Broadman's 1978 documentary, *Mission Hill and the Miracle of Boston*, a thirty-something interviewee looks back on his boyhood during a time when Harvard had just leaped across the Charles River from Cambridge and was aggressively checker-boarding its way into this working-class Allston neighborhood. "I don't know exactly how it is that adults communicate certain things to children," he reflects, "but we always knew it was okay to piss on those buildings."[4]

Decades later town-gown animosities flared once again. Pursuing what university administrators referred to—apparently without irony—as their Institutional Master Plan (IMP), Harvard had quietly acquired fifty-six more acres in Allston in the 1990s. (By "quietly," I mean secretly. Always represented by a third-party agent, Harvard's real estate activities, intentions, and its growing footprint remained entirely hidden from view. The university's holdings in Allston-Brighton are now more extensive than their more famous properties around Harvard Yard.) In 2008 Harvard razed several acres of former working-class housing in order to build a science complex, but the project stalled when the economic collapse suddenly altered the institution's financial outlook. The leveled acreage, known locally as "the big hole," sat dormant for several years until the university presented a new IMP in 2014. In the meantime, thousands of people had been displaced, and many businesses surrounding the big hole withered and died. This shopping center, at one time anchored by a Star Market and a Caldor department store, had gone completely dark by the time I visited in 2010. "They dug a five-acre hole, bigger than the Filene's Basement hole," says resident Chip Alford, "a lot bigger, and it's been there longer."[5] The palpable feeling along these streets when I visited was, *If only there were a building to piss on.*

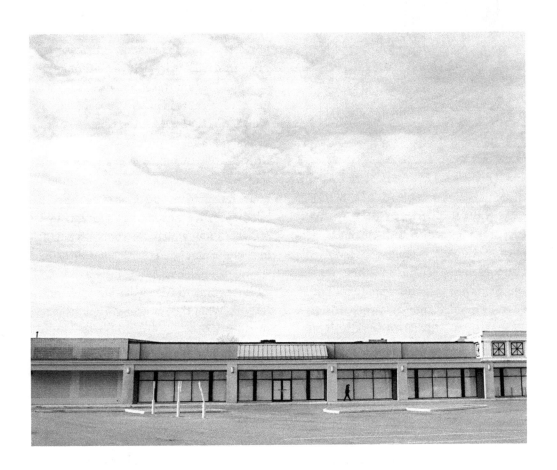

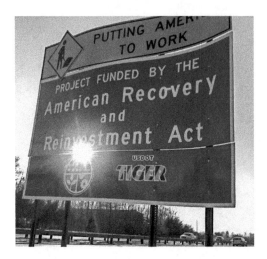

NEW HAVEN, CONNECTICUT, 2009

Part of the immediate anti-Obama backlash in early 2009 consisted of conservative critiques of his "socialistic" stimulus package. Signs like this one went up for both civically minded and narrowly partisan reasons, then—to reassure a skittish public that steps toward recovery were indeed being taken, and to see if perhaps Obama could get a little credit for local projects. It was a self-conscious, symbolic appeal to the New Deal. As Thomas Frank notes, having spent the decades since the Clinton years moving decisively away from New Deal–style governance, "in 2008 Democrats suddenly decided that the New Deal was back and that Franklin Roosevelt was more relevant than ever."[6]

The American Recovery and Reinvestment Act (ARRA) was a good, old-fashioned Keynesian intervention, to be sure, and when polled, a sizable majority of economists ultimately did conclude that "the U.S. unemployment rate was lower at the end of 2010 than it would have been without the stimulus bill."[7] But the bill did have its detractors, not only on the right, but increasingly on the left as well. Frank himself, for one, lamented, "If this was a modern-day New Deal, it was a timid iteration." Precious resources were squandered in tax cuts in order to attract Republican votes for ARRA in Congress, first of all; and other resources were lost for a truly Keynesian approach in arrangements that benefited consultants and entrepreneurs rather than workers. Though the bill did finance "the famous 'shovel-ready' projects about which everyone was talking in 2009," Frank writes with some disdain, "if you can name just one of them today without going to Wikipedia, you have my respect. What the sprawling stimulus measure did not include was the obvious thing, the most effective thing, the thing Americans of all ages remember that Franklin Roosevelt did—direct federal job creation in the WPA manner." Even so, at least one blogger would object strenuously to road signs like this one: every one of them marks "the detrimental effects" of ARRA, and "further brands socialism."[8]

NEW YORK, NEW YORK, 2009

Street demonstrations are performative, and documentary work is collaborative. My camera sought out the most photogenic person at this 2009 Times Square rally, and just as I raised my lens for the shot, the subject helped me out by making himself even more photogenic still. It was not until hours later, as I reviewed images from the day's shoot at my kitchen table, that I recognized what a perfect echo of the classic tragedy/comedy masks was being performed here, as this demonstrator posed with the departed Chanel Bunce. A sly and unscripted avowal of the theatrics of our coauthored creation.

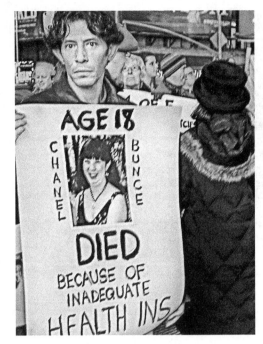

Performative, yes, but is it a put-on? What does the photograph teach? I am still haunted by the audience member at an academic presentation several years ago who said, "This photograph tells me nothing. There is not a single thing I can learn from it." But I am not as haunted by that as I am by the look in this subject's eyes. The years-long debate over Obamacare devolved into such a thicket of political acrimony and abstraction—"health-care dictatorship" (Newt Gingrich); "a crime against democracy" (Michele Bachmann); "the most ambitious power grab I've ever witnessed" (Rick Santorum)—that the political stakes have long eclipsed the human stakes in discussions of our health-care policy.[9] In its very affect, this image advances an unanswerable pedagogy on *these*, even if we can "know" nothing about this man or about Chanel Bunce. In 2009

thousands of people took to the streets upon the promise of health-care reform; the cares they brought with them into the fray were not about governance alone, but about affliction and suffering. This is the broader truth that the image documents and distills, even if its theatricality plays fast and loose with narrower, more specific truths.

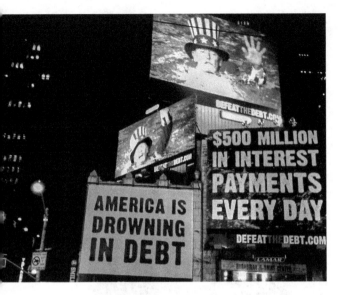

NEW YORK, NEW YORK, 2009

The epic, stories-high image of a drowning Uncle Sam comported well with a cityscape that was visibly pocked by signs of hardship and peril. "Losing the American Dream? MortgageHelpNow.org." "End Your Personal Recession Now. Cash for Gold." "Free Winter Clothes. Ropas Gratis." "Store Closing 70 percent Off." "Everything Must Go 90 percent Off." "Famous Dumplings—Recession Price $1.29." Now and then the commentary could be pretty droll—"Recession Sale! Adult DVDs $1.99"—but these were somber streets in 2009.

The story behind the Uncle Sam billboard is actually less economic than political, it turns out. A typical post on the Defeat the Debt Facebook page rails against "the welfare and regulatory state" as "a historical aberration."[10] When the national debt became an object of obsessive concern in 2009 and after, "deficit" and "debt" functioned as code words for Obama's brand of liberalism, and perhaps for his blackness

as well: consider Newt Gingrich's characterization of Obama as "the food-stamp president."[11] Uncle Sam's whiteness in this spectacle of peril might have been doing some subtle ideological work. Although the "Defeat the Debt" project of the Employment Policies Institute presented itself as a politically neutral public service campaign, the conspicuous fact remains that the EPI—like Tea Party protesters and, indeed, Republicans in Congress—had never had much to say about government over-reach throughout the Bush years, as conservative policy across two terms had spent down America's last surplus, increasing federal spending by 6.5 percent while decreasing tax revenues by 4.7 percent (as percentages of GDP).[12] Such was the course of "fiscal responsibility" that Barack Obama inherited along with the recession; yet even within just months of taking office, it was he whom many were bent on blaming. The Tea Party gist of much "neutral" economic analysis followed as quickly upon Obama's inauguration as the formation of the Tea Party itself.

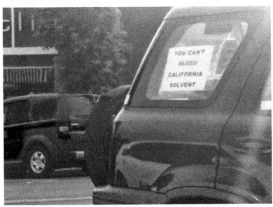

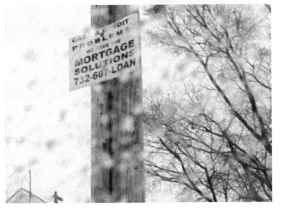

LOS ANGELES, CALIFORNIA, 2011

A little history, but not on the Haymarket bombing of 1886. After a U.S.-enabled coup in 1973, Augusto Pinochet turned the country of Chile into the first real laboratory of neoliberal governance. Through a web of institutions that included the U.S. International Cooperation Administration, Chicago University's School of Economics, the Universidad Católica de Chile, and Pinochet's ministries, a group of Milton Friedman disciples known popularly as "the Chicago Boys" established a "new economic order" within a few short years of Salvador Allende's overthrow. They deregulated prices, privatized state-controlled firms and banks, cut public employment, atomized unions and cut wages, and liberalized Chile's capital markets.[13]

Sound familiar? Whereas Milton Friedman once famously said "we are all Keynesians now,"[14] it is clear forty years on that *we are all Chileans now.* These policies had first been propounded by the conservative Mont Pelerin Society at mid-century. Their founding statement fretted over a declining faith in "private property and the competitive market; for without the diffused power and initiative associated with these institutions it is difficult to imagine a society in which freedom may be effectively preserved."[15] Thus begins the long march of the proposition that free peoples require free markets; that capitalism *is* democracy, that capitalism is *freedom itself.* As a mode of governance, the Chilean program would overtake much of the rest of the world after 1973. The version of "freedom" peddled here, as Karl Polanyi had presciently put it, was "the freedom to exploit one's fellows, . . . [and] to make inordinate gains without commensurable service to the community."[16] The early years of this neoliberal experiment marked a significant pivot point in the United States, as investment banking occupied a larger and larger share of the nation's economy, and as the politics of lending and debt rivaled the politics of extraction or export in its significance to both the nature and instruments of U.S. power. David Harvey calls this tendency in neoliberalism the "financialization of everything."[17] Stymied by the "common sense" of the market, it took some time for American public discussion to find a vocabulary for addressing these circumstances.

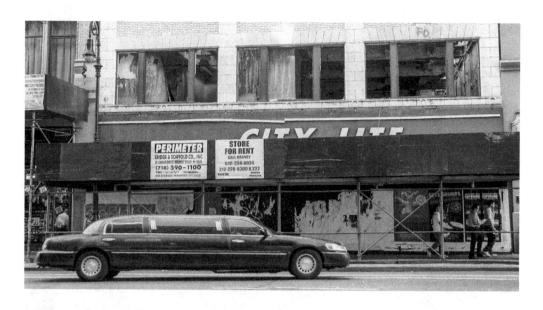

NEW YORK, NEW YORK, 2011

Neoliberalism advanced globally according to a web of supply-side, market-worshipping ideas about reduced public expenditure, tax reform, deregulation, competitive exchange rates, trade liberalization, secure property rights, and foreign direct investment. The rising imperative was to "set your house in order" and "submit to conditionality." Debt itself became an instrument to leverage specific behaviors on the part of debtor nations; the holy grail was "a good business climate" globally.[18] The cartography of this neoliberal regime expanded with breathtaking speed. By the mid-1980s "three-quarters of Latin American countries and two-thirds of African countries were under some kind of IMF–World Bank supervision."[19] The mobility of capital in the late twentieth century leveraged new levels of concession from government within the United States as well, in the form of tax breaks for corporations, for example, as states and localities raced toward the bottom. The debt crisis in Mexico was merely prelude to the debt crisis everywhere; and the financialization of everything has led irresistibly to the impoverishment of everyone.

Well, not everyone. The politics of austerity that is neoliberalism's bitter harvest has led one government after another to declare, "we're broke"; and while polities around the world—and across the fifty states now, too—have struggled with the word "broke," complex realities masked by the word "we" clamor for attention. Public coffers may be pitiable, but private ones most decidedly are not. Real wages fall, corporate profits rise; and aggregate wealth—much of it parked offshore or made otherwise untaxable—has not in fact declined. The Occupy movement, pitting the 99 percent against the 1 percent, was a quixotic exercise in parsing out that two-word sentence, "we're broke."

OAKLAND, CALIFORNIA, 2011

I had a shaggy, left-leaning friend in college named Tim who once elaborated his outlook on world history to his older, very conservative, gray flannel suit-type, businessman brother: "Civilizations ebb and flow," Tim said. "The Roman Empire rose and fell, Imperial China came and went, the sun *did* set on the British Empire, and the same will eventually have to be true of the United States. We'll be lucky if the 'American Century' lasts even that long. That's just how history moves." To which his brother shook his head and said, pityingly, "You're so negative."

History was probably on Tim's side, but, in a general way, American thinking was on his brother's. *Time Magazine* defied a deep and quite impressive current of national hubris with this cover story in 2011. I photographed this magazine on the stand as an historical event in itself, then, no less spectacular in its way than the carcasses of Bethlehem Steel, the old Packard plant in Detroit, and any number of other sites suggesting that, as my friend Jonathan Flatley put it, "Capitalism is all done with the American worker." Serious talk of decline might conceivably have begun decades ago—Michael Moore's *Roger & Me* depicted a dying Flint, Michigan, as the canary in the coalmine of late capitalism way back in 1989, and Robert Reich's *The Work of Nations* puzzled out the emergent, vexed relationship between nation-states and multinational capital in 1991. But at that time, American discourse fixed upon immigration rather than the mobility of capital as the root of our problems. The extent to which Americans obsessed over

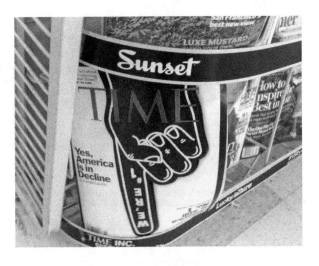

immigration, in fact—Pete Wilson, Proposition 187, best sellers like Peter Brimelow's *Alien Nation*—is precisely the extent to which we failed to debate and theorize the social realities that globalization was ushering in. The economic and xenophobic critiques of globalization have now converged, as evidenced by Donald Trump. But many years of valuable time for analysis and policy adjustment were lost between the Cassandra-like warnings of *Roger & Me* and the "1 percent" formulation of the Occupy movement. In the meantime, the manufacturing sector shrank, and a growing and ever more adventurous financial sector began bundling mortgage-backed securities and concocting fantastical instruments like the credit default swap: on one front the mid-century American Dream of modest means, modest security, and modest mobility was in retreat, while on another modesty itself was decisively extinguished. By 2011 many were ready for *Time*'s headline, even if it was "so negative."

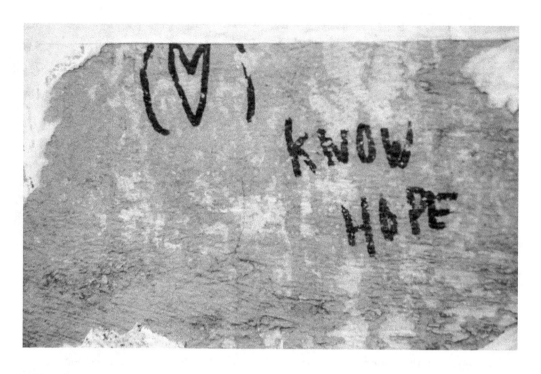

NEW YORK, NEW YORK, 2011

"Post Mad Bills," read one mirthful sticker on a lamppost in Manhattan, in rebuttal to the standard "Post No Bills" signs that grace many city surfaces. And people often do. Historians have long noted the significance of reading practices to the processes of urbanization and the nature of urban life. Lewis Mumford called the city itself "a special receptacle for storing and transmitting messages."[20] But what interests me more here are the practices of *expression*. The unending discussion embodied in stickers, marquees, billboards, graffiti, and "mad bills" of every sort represents an important and undertheorized form of communication in our public culture, a poignant sign of alienation and a ceaseless

yearning to talk back. In an environment where the public commons are increasingly commercialized and where the very idea of a broad democratic public has given way to the narrow ideological boutiques and niches of cable news and the internet, the visual cacophony of this signage accomplishes important work on behalf of individualized expression for a broad audience of chance comers. In this instance, the delicious double entendre — know hope, no hope — captures the sentiments of a polity on edge, a political culture seemingly primed to deliver up its very best or its very worst at any moment.

NEW YORK, NEW YORK, 2011

There was plenty of mirth in these "TAX THE RICH" crowns at an Occupy event in Manhattan, but this sentiment, frankly spoken, also marked the beginnings of a serious reversal in mainstream discussions of taxation in the United States. Americans had traveled a long road from the Revenue Act of 1935, whose popular moniker as the "soak the rich tax" expressed a frank and widespread approval of a 75 percent marginal rate on the nation's wealthiest citizens amid the national crisis of the Great Depression. But the tax revolt of 1978 and Reaganomics in the 1980s at once articulated and installed a new, post–New Deal orthodoxy regarding the relationship between taxes and collective prosperity. "Tax-and-spend," as a species of accusation, became an albatross around the neck of traditional liberalism in this environment; and any suggestion of an increase in taxes—even when all evidence indicated its necessity—became the "third rail" in American politics. ("Read my lips.") Soon liberals began to run away from the word "liberal" itself, and by the Clinton years it had come to seem a law of nature that the income-tax rate for the highest bracket would be about half what it was only a generation earlier. (George W. Bush would lower this even further.)

Many still debate the "achievements" of the Occupy movement, and in terms of both policy and movement formation, the verdict is still out as of this writing. But in popularizing the shorthand formula-

tion of the 1 percent versus the 99 percent, Occupy fundamentally altered the rhetorical and logical terrain upon which American policy debates are now staged. Many draw a straight line from Occupy to Proposition 30, for example, which reintroduced a logic of tax increases on the rich in Jerry Brown's California in 2012. And to good effect. Notably, in 2016 even a "Clinton Democrat" like Hillary ran with proposed tax increases out in full view.

NEW ORLEANS, LOUISIANA, 2010
This is a sentiment encountered more
and more frequently in the wake of *Citizens United*, and one that fully defined the
Bernie Sanders campaign in 2016, though
it had been drowned out for many years by
contrary fears on the right that *government*
posed the more serious threat. The years
since the 1970s have gradually exposed a
complicated dual development in the re-

organization of global power and wealth:
alongside the long-standing interventionist
policies that carried the United States into
Nicaragua or Iraq, these years have also
witnessed a maturation of a certain variety
of imperial domination without—driven
by finance, enacted by banking institutions for the benefit of multinational corporations—and a concurrent evisceration
of the United States' domestic life within.
Though the "financialization of everything"
has certainly benefited the United States
(the lone superpower does crucially remain a "power" in this equation), certain
aspects—like deindustrialization—have
been traumatic even on the home front.[21]
This triumph of neoliberal empire finally
created the conditions within the United
States that would plausibly look to some
like the *fall* of the empire. U.S. citizens increasingly feel helpless before corporations
and institutions of global finance that have
begun to treat them the way they have
been treating the so-called Third World for
several generations. "Due to the dismantling and remodeling of traditional safeguarding systems," writes Isabell Lorey,
"every form of independence disappears
in the face of the dangers of precariousness and precarization. . . . Even those
who were previously secured at the cost of
national and global others are losing social
protection."[22]

BERKELEY, CALIFORNIA, 2010

The triumph of neoliberalism represents a revolution in the realm of governance and citizenship. Nothing symbolizes this more powerfully than the current state of public education. Students in my twentieth-century survey are always shocked to learn that, when Mario Savio famously exhorted his comrades in the Free Speech Movement from the steps at Sproul Hall, neither he nor his Berkeley classmates had paid a dime in college tuition. Such was the social contract in 1964.

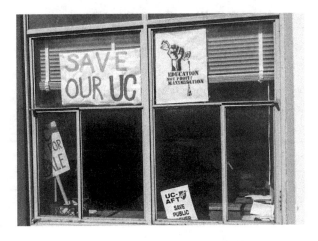

In the decades since, the culture's thoroughgoing saturation in the logic of market rationality—its heightened resistance to taxation and a generalized calculation of cost-benefit as the chief measure of "good government"—has impoverished public coffers and fully decimated the "public" itself as a cohesive body with a sense of common interest and collective destiny. As Wendy Brown writes, "A fully realized neoliberal citizenry would be the opposite of public-minded; indeed, it would barely exist as a public. The body politic ceases to be a body but is rather a group of entrepreneurs and consumers . . . which is, of course, exactly how voters are addressed in most American campaign discourse."[23] The ideas and institutions of liberal democracy had at one time established a formal distinction between moral and political principles on the one hand and the economic order on the other, thus insulating citizens from "the ghastliness of [a] life exhaustively ordered by the market."

But neoliberalism ruthlessly closes this gap.[24] The United States' disfigured college campuses and debt-shackled students, its crumbling urban schools and collapsing bridges do not simply represent the collateral damage of economic practices, but—more portentously—are outward manifestations of a fundamental change in the meaning of the "civic" and in the nature of the "citizen."

NEW YORK, NEW YORK, 2010

At the World Economic Forum in Davos in 2011, JPMorgan Chase chief executive Jamie Dimon complained of the pitchfork-wielding mob that was encircling the post-crash financial community. "I just think this constant refrain 'bankers, bankers, bankers'—it's just a really unproductive and unfair way of treating people," he said. "And I just think people should stop doing that."[25] To which many replied, *Poor thing.* The deeper history of the mob he was envisioning surely ran back through the WTO protests in Seattle in 1999, and from there to earlier iterations of critique like SDS, the Popular Front, the Wobblies, the People's Party, and the Farmer's Alliance. Actually the United States has quite a rich tradition when it comes to "this constant refrain 'bankers, bankers, bankers,'" considering we are supposedly a "classless" society.

But the particular formation that Dimon was lamenting dated approximately to this March on Wall Street in April of 2010. In one sense this was a good, old-fashioned union rally—AFL-CIO President Richard Trumka had called the march in response to reports that Wall Street was trying to block financial reform. But in another sense, it was something much bigger: it was the moment when "banking equals theft" ceased being a wild, Marxist proposition and became an element of mainstream American discourse. "Madoff Was a Scapegoat, You Are All Criminals," read placards in the crowd. Within months,

Americans were making best sellers out of books with titles like *Bailout Nation: How Greed and Easy Money Corrupted Wall Street and Shook the World Economy.* Popular—if not popu*list*—disaffection had been manifested immediately in 2008, as the Emergency Economic Stabilization Act (the bank bailout) was being debated; but it was in 2010, as the public weighed the idea of a $700 billion bailout at taxpayer expense against news that Wall Street was still rewarding itself with $20 billion in bonuses *and* was resisting meaningful reform, that a renewed vocabulary of class and political economy was restored to public discussion. Sectarian critiques of the New Left's post-1960s "detour" into identity politics can be overdone—Todd Gitlin once decried "the aggrandizement of difference" or "the cant of identity," though Robin Kelley rightly notes that no "Left" worth its salt in a country like the United States can neglect issues of race, gender, or sexuality, given the ways that these, too, have structured power.[26] But it is true that popular debate on questions of class had been quite anemic for at least the past two generations. As a ready, vernacular way of looking at the world, the formulation of "the 99 percent and the 1 percent" started here, amid the calls to "Hold Banks Accountable" and "Reclaim Our Democracy."

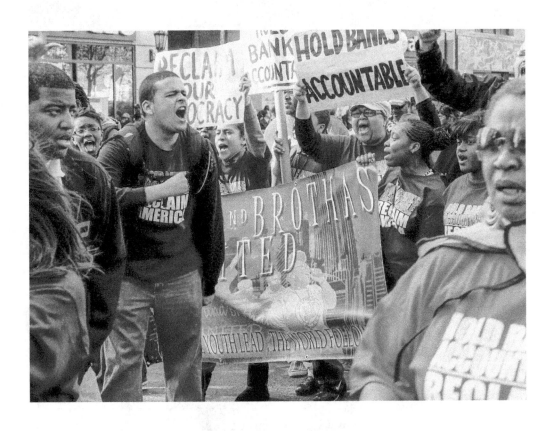

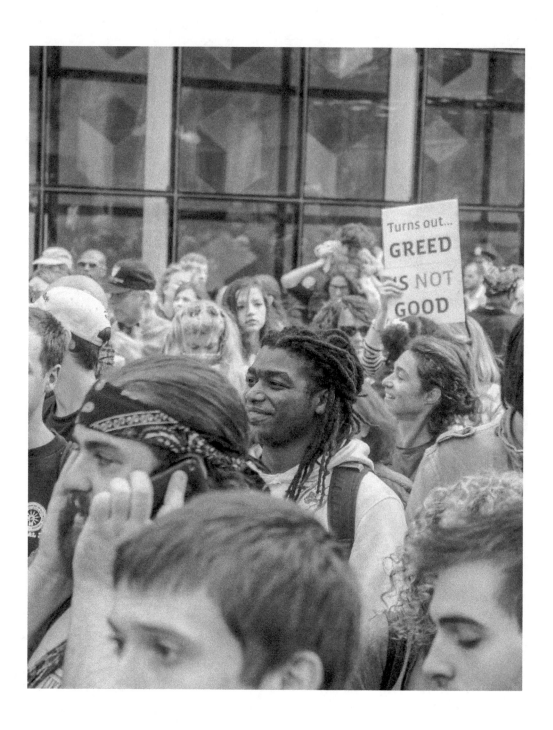

NEW YORK, NEW YORK, 2011

One of the most memorable scenes in all of U.S. politics was when, at the Army-McCarthy hearings in 1954, attorney Joseph Welch stopped a hectoring Senator McCarthy cold: "You have done enough. Have you no sense of decency, sir, at long last? Have you left no sense of decency?"[27] This became iconic, not simply because it represents the moment of downfall for a demagogue who had been bullying the nation for four years, but because it underscored for posterity that at the end of the day, politics is after all, "at long last," about *decency*—kindness or meanness, fairness or self-dealing, generosity or cruelty, honesty or duplicity—*decency*. There are many dimensions to Americans' experience of the crash in 2008 and after, enough to keep economists, historians, political scientists, anthropologists, and sociologists all busy for some time. But also moral philosophers. Max Weber once posited that the corporation as a legal form was created to carry out those things that capitalism requires but Christianity forbids. As the facts of the financial collapse became known and the hidden realities of the subprime crisis and the bailout came into public view, a *moral* nerve was struck across the nation, and this is probably why the formulation of "the 1 percent" lives on, even though Occupy Wall Street seems to have come and gone. Even if losing out on many key policy questions, a widespread moral outrage emerged in the wake of the crash—not just wonkish policy proposals, banking reforms, or tax schemes, but also public attention—from op-ed pages to best-selling books to Hollywood films like *The Big Short*—to core questions about institutional integrity and the equity of the prevailing system, and to bedrock virtues like honesty, trust, honor, and accountability. By the time of Occupy, the question was not only what Wall Street had done to the rest of us, but what the Street's fate had been as a result. As journalist Chris Hayes put it, faced with "black kids dealing weed in Harlem and investment bankers peddling fraudulent securities on Wall Street," a just society might either forgive both, or hold both accountable. "[W]e cannot have a just society that applies the principle of accountability to the powerless and the principle of forgiveness to the powerful. [But] this is the America in which we currently reside."[28] There is no small irony in the fact that billionaire Donald Trump would present himself as Americans' savior from this "rigged system." Depravity is alive and well. But our injured collective moral sense is real, Trump notwithstanding, and just as the principled, warmly human language of *decency* was the only thing that could put a stop to McCarthyism, it may well be all we have to cut through the culture's default bias against "class warfare" in order to address the realities of plutocracy.

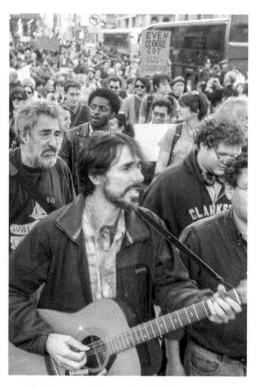

NEW YORK, NEW YORK, 2011

Just as the 1930s will forever provide the anchoring point of reference in American conceptions of economic hardship, so the 1960s will forever index the modes and contours of mass mobilization and protest. The guitarist at this Occupy Wall Street march cannot help but be citational — a surrogate for Bob Dylan, Phil Ochs, Joan Baez, Odetta, and for the mass demonstrations of American memory. (In its own day, the 1960s folk revival itself surrogated Old Left figures like Woody Guthrie and the Depression-era heroism of the Popular Front.) This image, shot from atop a newspaper vending machine as the crowd rolled past, codes a familiar kind of American radicalism in tacit idioms of nostalgia. But I would argue that the guitarist's flesh-and-

blood presence did the same for those who saw and heard him amid the tumult that day; perhaps it even lent the fortitude of a protest *tradition* to some for whom marching in the streets was an unaccustomed act.

Backward-looking romance gets a bad rap — perhaps properly so; the historical analogies that are written into this kind of collective memory are not without their hazards. The activists of Black Lives Matter, for instance, have run into some unexpected resistance within the African American community itself, because their methods comport poorly with an older generation's preconception of what civil rights protest *is*. But in a nation where the historical circuits of progressive politics have been so regularly disrupted, a wistful nostalgia for earlier struggles may do some important and productive work. As Vijay Prashad points out, because the American Left has been so thoroughly and repeatedly decimated (think McCarthyism, think COINTELPRO), stores of radical knowledge and tactical expertise have been only spottily and unreliably passed from one generation to the next on the American Left.[29] That the Left would find its way from the CIO's occupation strikes in the 1930s, to the occupation of university buildings in the 1960s, to Occupy Wall Street in the 2010s was certainly not a foregone conclusion, given the perils along the way. Across this arc, Left publics in the United States have been continuously recultivated and remade through the critical work that culture does. Folk music has been among the significant cultural forms of sustenance in this respect. Romance, this photograph suggests, has perhaps been another.

NEW YORK, NEW YORK, 2011

"To be a participant in politics," writes Judith Butler, "to become part of a concerted and collective action, one needs not only to make the claim for equality (equal rights, equal treatment), but to act and petition within the terms of equality, as an actor on equal standing with others. In that way the communities that assemble on the street start to enact another idea of equality, freedom, and justice than the one that they oppose." The form of resistance itself, she explains, "the way communities are organized to resist precarity, ideally exemplifies the very values for which those communities struggle."[30]

This to me was the "born again" of the Occupy movement—not just the demand for a better world, but the nascent enactment of one. There was an unbridled joyousness in these Occupy events that cannot be explained in any other way. I witnessed it firsthand at Occupy marches and encampments as far-flung as New York, Baltimore, Cleveland, Boston, Charlottesville, New Haven, Los Angeles, and Oakland. Butler's analysis of assembly suggests the theory behind the phrase *We are the ones we've been waiting for*, a popular saying on Occupy placards. Although the line is from June Jordan's "Poem for South African Women" (1978; it later provided the title for both a song by Sweet Honey in the Rock and a book of meditations by Alice Walker), by 2011 it was widely and mistakenly attributed to Barack Obama, who had cited it in a campaign speech in 2008. While the relationship between Occupy and Obama could be vexed (I saw a banner at one rally that asserted flatly, "Obama =

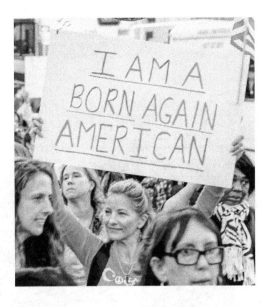

Bush"), Obama's "We are the ones we've been waiting for, we are the change we seek"[31] did fairly describe the utopian enactments at Zuccotti Park and elsewhere, and defined what "born again American" meant at the dawn of Occupy. In Butler's terms, the unity, the warmth, the egalitarian spirit, the good cheer, the humor, the collectivity, and the participatory nature of Occupy's forms of resistance and its political rituals—the human microphone, for instance—at once expressed and embodied the values and the version of democracy for which this community was in struggle.

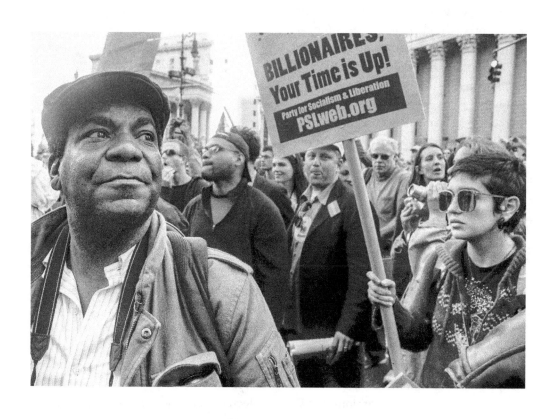

NEW YORK, NEW YORK, 2011

Encamping at privatized public spaces like Zuccotti Park, rallying at truly public spaces like New York's City Hall or the steps of State Supreme Court Building, the Occupy movement traversed an ideological terrain that could encompass frankly radical critiques (hence the Party for Socialism and Liberation here) and quite traditional appeals to civic values. As one activist in Occupy Charlottesville told me, "What we're doing isn't novel, it's not revolutionary. It's actually traditional. What people used to do is they used go to public spaces and have discourse. That doesn't happen anymore, and we're actually being criticized for doing it."[32] Alongside roguish slogans like "Unfuck the world," Occupy placards offered philosophical observations like, "In times of universal deceit, speaking truth is a revolutionary act."

A signboard at the Zuccotti Park encampment greeted passersby, "You can stare, you can make fun . . . But we are here not just for us, but for you too! We are here because of the high rents, job loss, high tuitions, gas prices, the loss of pensions and social security, health care, losing our homes, fare hikes, leaders that don't care, 9/11 responders, + more. No more fear!!!"[33] Embedded within such statements and within Occupy's rhetorical formulation of the 1 percent and the 99 percent was a vernacular critique of what academic theorists have termed *precarity* under emergent neoliberal regimes. "Capital accumulation and economic growth have gone separate ways," writes Wendy Brown, "in part because the rent extractions facilitated by financialization are not growth inducing." Here is the distance that has been widening between the 1 percent and the 99 percent over the past several decades: "productivity" no longer necessarily translates into either wages or jobs for regular folk. The financialization of everything has "altered the figure of human capital from an ensemble of enterprises to a portfolio of investments."[34] While Occupy's attention to economic inequality spoke most obviously to the fate of the old, Fordist working and middle classes under the new oligarchy of casino finance, the full catalogue of Occupy grievances — unaffordable rent and tuition, un- and under-employment, gutted pensions and welfare programs, fare hikes for reduced services, and safety-net failures — protested neoliberalism's mainstreaming of precarity as both a mode of discipline in the economic sphere and — as embodied in ubiquitous "austerity" measures — a mode of governance in the civic sphere. Though illegible to many, Occupy represented a fitful beginning in a politics of "de-precarization." Or, you know, unfucking the world.

NEW YORK, NEW YORK, 2011

The relationship between Occupy and law enforcement became complicated very quickly. An ecumenical and perhaps preemptive sign at the Zuccotti Park encampment could insist, "THE 99% INCLUDES COPS"; but in an era of privatized public spaces and of "free speech *zones*," it was only a matter of time before police and the Occupy movement would be in direct conflict.[35] At an early Occupy rally, an Inspector Deputy pepper-sprayed a group of protesters who had been corralled and penned in orange security netting by his fellow officers. The casual, almost offhand pepper-spraying of students at UC Davis became a cause célèbre a few months later. Such clashes led one Occupy marcher to fashion a signboard helpfully suggesting, "Pepper spray Goldman Sachs."

"Does freedom of assembly depend upon being protected *by* government," asks Judith Butler, "or does it depend upon a protection *from* government?"[36] The visual and social bifurcation in this image hints at a similar question. Race dominates our national discussions of policing and police violence, and rightly so: people of color have unquestionably been on the front line in citizens' battle against over-policing. But even the issue of racial profiling and racial imbalances in criminal justice points to the broader question that Butler poses. Racial tensions in Ferguson, Missouri, we learned, were directly tied to municipal fiscal policies that rendered citizens vulnerable to a kind of ad hoc taxation through

the relentless fines and fees attached to low-level but aggressively policed infractions. The encounter that ended in Eric Garner's death in Staten Island similarly began with the common street-corner harassment associated with "broken windows" policing. We cannot forget law enforcement's roll call of casualties among people of color. But the broader fabric that is implicated here, as Butler suggests, has to do with a core philosophical question of citizenship and the state under current conditions. What shall constitute concepts like "public safety" and even "the public interest" in a setting where "the public" itself has been atomized out of existence—where "corporations are people," where the wealthy have retreated into a rarified world of gated communities and private schools and untaxed income, where some fire departments operate on a fee-for-service basis, where "emergency financial managers" can be installed to replace duly elected officials, where even prisons are run privately and for profit? To protect and to serve *whom* is a racial question to be sure, but it is not exclusively that. Protection by, or protection from? No wonder the fellow on the left looks so stressed out.

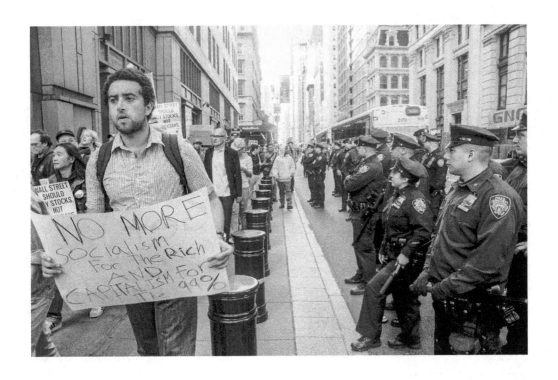

NORTH BRUNSWICK, NEW JERSEY, 2010

The collapse left a thousand different kinds of scars across the landscape. Localities like North Brunswick, which were struggling as it was (upwards of 8 percent unemployment in 2009), were further beaten and pocked by national trends, as when the grocery-store chain the Great Atlantic & Pacific Tea Company (A&P) announced the closure of twenty-five Pathmark locations in five states in 2010. Business analysts attributed the "under-performance" of these stores not to the crash, per se, but rather to a combination of A&P's overly aggressive growth in the previous years, market saturation, and heightened competition from rival ShopRite.

But aggregate trends and the strategic adjustments of executives in remote corporate headquarters do not necessarily answer the local psychology of loss. This vacated space, its degraded signage oddly radiating absence, is like an open wound, one injury among many along the Route 1 corridor between New Brunswick and Trenton. "I would say that it's a dire moment," Cliff, a bookseller in nearby Princeton, told me in an interview. "I think it's a moment of disillusionment both in American culture and American society. I don't think it's been realized yet—I think there's still this fantasy that the day before the recession could come back at any moment, and all it really takes is re-inflating some balloon . . . [But] it doesn't look like there's going to be a recovery in jobs. The private sector I wouldn't rely on, the government isn't hiring, the universities and public spheres are not hiring—" Here Cliff's partner Dorothea interjected, "And no one ever talks about wages. There's unemployment, and then there's wages. Even those who have jobs, can they live on one job?" "What does that mean for this incredible American fantasy of upward mobility?" Cliff asked. Our conversation had begun with a question about what the phrase "this historical moment" meant to them. "For me," Dorothea now reflected, "the Obama moment was unbelievable as an experience of hope in the political arena—an identification that you had gotten used to thinking that you could never *have* with the mainstream in politics. It was thrilling. . . . I was more hopeful than skeptical, for sure. . . . [laughs] I'm not riding so high any more."[37]

NEW YORK, NEW YORK, 2012

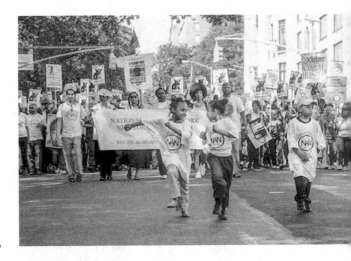

The horror of the Trayvon Martin shooting some months before hung heavily in the air over this protest against the NYPD's overtly racialized stop-and-frisk policy. The nation's gruesome roll call in the years since has become unbearable. Dontre Hamilton, Eric Garner, John Crawford III, Michael Brown, Ezell Ford, Dante Parker, Tanisha Anderson, Akai Gurley, Tamir Rice, Rumain Brisbon, Jerame Reid, Tony Robinson, Phillip White, Eric Harris, Walter Scott, Freddie Gray, Laquan McDonald, Alton Sterling, Philando Castile, Terence Crutcher. Google them. The list of the dead, of course, has been accompanied by an equally unnerving list of not-guilty verdicts and acquittals, beginning with George Zimmerman. The history of racialized policing runs much, much deeper than most Americans know. In a setting where slave revolts and Indian wars were the most obvious threats to the settler "democracy," the foundational concept of "domestic tranquility" enshrined in the Preamble to the Constitution was racialized from the very beginning. As Robin D. G. Kelley writes, "Justice was always going to elude Trayvon Martin, not because the system *failed*, but because it worked." Our legal foundations rest on "an ideology in which the protection of white property rights was always sacrosanct; predators and threats to those privileges were almost always black, brown, and red; and where the very purpose of police power was to discipline, monitor, and contain popula-

tions rendered a threat to white property and privilege."[38] No criminal justice system incubated for generations within this logic is going to achieve "race neutrality" without a struggle, and a struggle across centuries at that. Trayvon Martin could not stand *his* ground, because in the U.S. imaginary there is not ground that was his to stand on.

The presence of children at this demonstration—like their counterintuitive joy in the moment—speaks to that same history of U.S. assumptions about order and menace. In the vernacular white imagination, as in the unwritten doctrines of police methodology, phrases like "the black community" do not necessarily conjure images like this one. *But it is a community.*

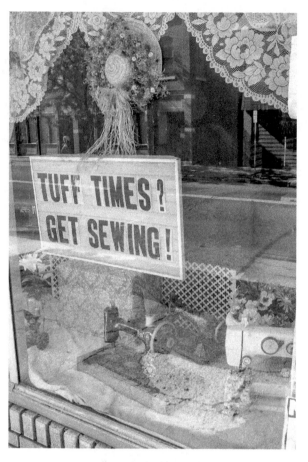

BINGHAMTON, NEW YORK, 2010

Downtown Binghamton was among the most relentless stretches of economic grief that I walked in my Great Recession travels. Darkened windows, some boarded or papered over, and hasty erasures of the old signage trumpeting now-defunct businesses, defaced block upon city block as one progressed along Main Street. Unemployment in Binghamton had shot from 3 percent to 10 percent between 2007 and 2010, topping 12,500 unemployed workers

at the recession's regional nadir.[39] The evident suffering was perhaps made all the more demoralizing in contrast to the many relics of the city's past grandeur, architectural monuments to boundless mercantile possibility still standing here and there, dating back to the flush times of the canal and early railroad period in the midnineteenth century.

The exhortation here to "get sewing" might represent a gritty kind of can-do selfreliance, reminiscent of Ma Joad and now suddenly appropriate in 2010—homespun clothes for those who can no longer afford store-bought. Or it might represent a wry suggestion for idle hands amid economic collapse. But it certainly also represents a brand of recession-era marketing that became quite common in storefronts and signage across the country—"Have a job? Get a car!" (Saint Paul); "Financial Crisis! 50 percent off living rooms bed rooms" (New Brunswick); "Times are hard, I am here to help / economic relief / 40 percent off all dry cleaning" (New York); "Recession Special! Save $1.00 on hot dogs" and "Famous Dumplings—Recession Price $1.29" (both Manhattan). There are competing readings here—mildly predatory opportunism? last-ditch desperation?—but I always liked these signs when I ran across them. Even in their commercialism and commodification, to me they also speak of collectivity.

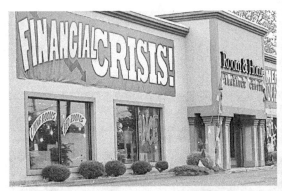
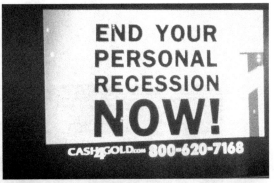
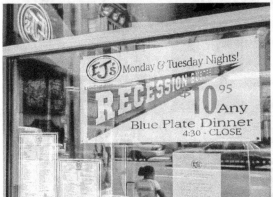
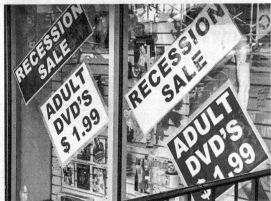
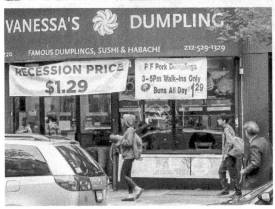

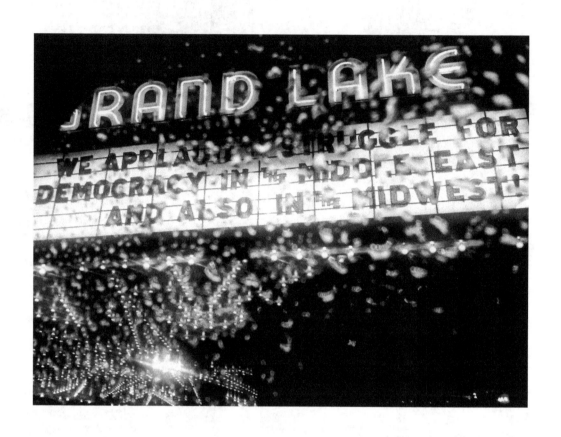

OAKLAND, CALIFORNIA, 2011

The Grand Lake Theatre has long been famous locally for its bold and resolute signage. "This is America / Every Vote Should Be Counted" (2000). "This Is a Nation of Laws! Impeach and Convict America's Worst Ever 'President'" (2006). Or, in the wake of her perceived strong-armed tactics in clearing Occupy Oakland from Frank Ogawa Plaza, "No One Can Evict an Idea Whose Time Has Come / Shame on You Mayor Quan" (2011).

This iteration cheers on the uprisings of the Arab Spring, a spirit of democratic protest in Tunisia in late 2010 that swept across Egypt, Libya, Yemen, Syria, Bahrain, Algeria, Morocco, Iraq, Jordan, and beyond in the early months of 2011. By February, as the marquee wryly notes, the Arab Spring had reached Wisconsin. These protests began in earnest on Valentine's Day, 2011, when the Graduate Student Employees' Union at the University of Wisconsin rose up against Governor Scott Walker's proposed Assembly Bill 11, a neoliberal effort—amid an asphyxiating set of tax cuts—to roll back compensation and benefits and to eviscerate the bargaining rights of public employees. By early March, the daily protests at the state capitol were drawing upwards of 50,000 people, including students, faculty, public employees, and a broad cross-section of citizens. At a rally on March 11, decrying Walker's "budget repair bill," dairy farmers from the surrounding region paraded through Madison on their tractors in surprising

solidarity with the activists of the college town. The mean spirit of Walker's policies surfaced elsewhere (Michigan, Kansas, Florida, North Carolina); the scale of the Madison protests generally did not. But the slogan "we are all Wisconsin" did show up on bumper stickers and random graffiti across the United States in these months, at once echoing and honoring the "we are all Tunisia" of the Arab Spring.

BALTIMORE, MARYLAND, 2011

Like neoliberalism itself, our ongoing culture wars in the United States date from the Nixon era. "Our children have been taught to be ashamed of our country," Nixon lamented in his second inaugural address in 1973. "At every turn, we have been beset by those who find everything wrong with America and little that is right."[40] In the place of the New Left that Nixon was complaining about, we have seen a proliferation of distinct "left publics"—a civil rights Left, a Third Worldist Left, a feminist Left, an LGBT Left, a labor/unionist Left, an anti-war or anti-imperialist Left, an environmental Left, and also several groups defined by occupational niche more than social location, such as a legal Left, a university Left, an artistic Left, a Hollywood Left. This kaleidoscopic assemblage of diverse left *publics* might partially align for a given cause, but its staggering diversity, specialized interests, and discrete priorities have made it difficult for old institutions like the Democratic Party or new ones like MoveOn to pull together and manage as a working coalition. One thing they have all shared for sure, however, is some version of disenfranchisement, vilification, or outright demonization along Nixonian lines.

In spirit and substance, this denizen of Occupy Baltimore rebuts Nixon (Reagan, Bush, Gingrich, Limbaugh, Beck, Palin . . .) and their "love it or leave it" brand of American patriotism, as well as the garish nationalist fundamentalism of the Tea Party. It is easy to forget that Occupy Wall Street also began with a tweet that invoked the American Revolution: "Dear Americans, this July 4th, dream of insurrection against corporate rule #occupywallstreet."[41] Economist Joseph Stiglitz had fired the first salvo in his May 2011 *Vanity Fair* article decrying the state of American governance, "Of the 1 percent, by the 1 percent, for the 1 percent"; soon Occupy was taking shape, if not as a "movement," at least as "a verb in search of a noun."[42] But patriotism was at the center of the contest, just as surely as policy was. Given the Nixonian roots of so much of this contest, it was fitting that Norman Lear, of *All in the Family* fame, would come to Occupy's defense: "Call it the American dream, the American promise or the American way. Whatever term you use, it is imperiled, and worth fighting for. It is that basic, deeply patriotic emotion that I believe is finding expression—bottom-up, small-d democratic expression—in the Occupy movement. We can, and I would say must, fully embrace both love of country and outrage at attempts to despoil it. What better cause? What better time?"[43] Occupying Wall Street meant reoccupying American patriotism.

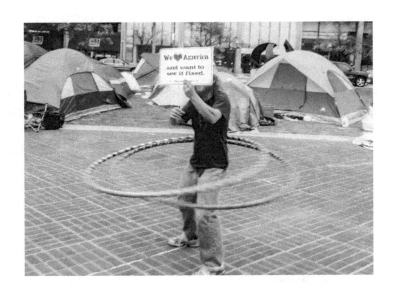

NEW YORK, NEW YORK, 2011

A Zuccotti Park idyll. I shot this at a time when Occupy Wall Street was being loudly denounced in some quarters for its to-the-barricades, Paris Commune revolutionism, and in others for its unwelcome return to the Summer of Love—not so much a counterculture as an anticulture. "These kids should take a bath," huffed Newt Gingrich on Fox News. "How about you occupy a job," demanded Rudy Giuliani, continuing, "Woodstock is a lot more fun than working eight hours a day."[44] So here is an image that doesn't exactly say "insurrection"; nor does it suggest joblessness, freeloading, or, for that matter, indifferent grooming. On my own visits with occupiers and their fellow travelers in several cities, I was struck by the vast distance between what the media were saying and what I was seeing with my own lying eyes. Yes, over the weeks these encampments took on the bedraggled look you might expect of a site where scores of people were sleeping out of doors for long periods of time. ("I was occupying The Green before it was fashionable," one homeless gentleman in New Haven told me.) But *they should take a bath and get a job* was not the first thing you were likely to think when you actually spoke to these people. At least not me.

Later, when this photograph appeared as part of a gallery exhibition in New Haven, one reviewer wrote approvingly of it as an *anti*-Occupy statement on my part—a jab at these "rise of consciousness" folks who didn't even know how to spell the word *consciousness*. Believing is seeing, as Errol Morris notes—someone who was already scoffing at Occupy was only going to see this photograph as evidence of the movement's scoff-worthiness. As a professor, I guess I was supposed to care about the misspelling (or at least notice it); but my thinking was running in a different direction. What the critic's comment says about the instability of *meaning* in photography—Morris remarks on "our collective need to endow photographs with intentions"[45]—actually interests me less in this instance than the contradictory, mystified "readings" of Occupy itself that have multiplied. "What does Occupy *want*?" was a question one heard again and again in 2011, as if its very novelty made it at once irresistibly bewitching and completely indecipherable. "Occupy did not cringe in the face of authorities," writes Todd Gitlin, and this trait was bound to compel the attention of friend and foe alike. "It did not feel that they—politicians, police, or anyone else—held any rights superior to their own. Occupy was not given to pleading or lamentation, or, necessarily, what others might call good manners. . . . 'Whose streets? Our streets!'"[46] Piercing the grim darkness of the atomized, neoliberal city, this did strike me at the time as a "rise of consciousness."

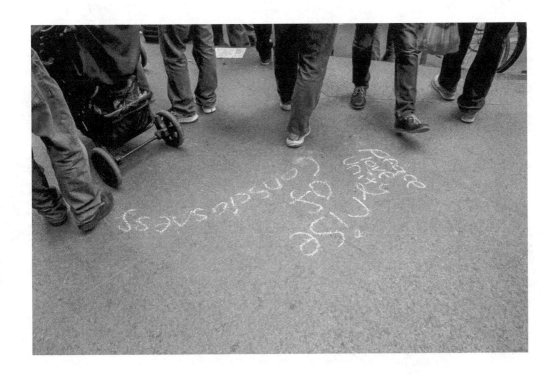

3

Space Available

NEW YORK, NEW YORK, 2009

The ubiquitous "SPACE AVAILABLE" and "STORE FOR RENT" signs across our cities and towns are conspicuously inconspicuous: we are meant to notice them as potential buyers or tenants, perhaps, but never as social observers—never as the *citizens* of a society whose ways of getting a living have been eviscerated. They invite commerce, but not reflection. In early 2010 the *New York Times* reported the equivalent of 920 football fields of vacant commercial space in Manhattan alone.[1] Something like this has turned out to be true most everywhere I have traveled—Los Angeles, San Antonio, Minneapolis, Gainesville, Binghamton, Lexington, Chehalis. One readily finds specimens of virtually every sort of abandoned property, too—factories, car dealerships, supermarkets, entire shopping centers or strip malls, roadside motels, small retail storefronts, tiny bodegas, giant box stores. In a 2009 interview, Bonnie Fox, at the time an unemployed office manager in New York, helped me to understand the significance of the "SPACE AVAILABLE" sign.

> Well this is the Upper East Side. And now all of a sudden—and it's not because of the Second Avenue subway and all the construction that is going on about that—but I walk up and down: First Avenue, Second Avenue, and Third Avenue, and Lexington Avenue, and everywhere I look businesses are closing. *All kinds* of businesses. And

I think, this is really frightening. And they're not reopening. Nobody's taking over the space.[2]

Fox spoke of the loneliness of the job search in the modern era. Both the search for aid and the search for work are conducted mostly online, with little actual human contact and only seldom a glimpse of any of the millions of fellow searchers. No relief lines, no bread lines, no unemployment lines—unlike the 1930s, no natural gathering places to note and process a communal experience. In this environment, the omnipresent "SPACE AVAILABLE" sign denoting a recently departed business is among the only public markers we have of the scale of our economic distress. The following gallery requires no further commentary.

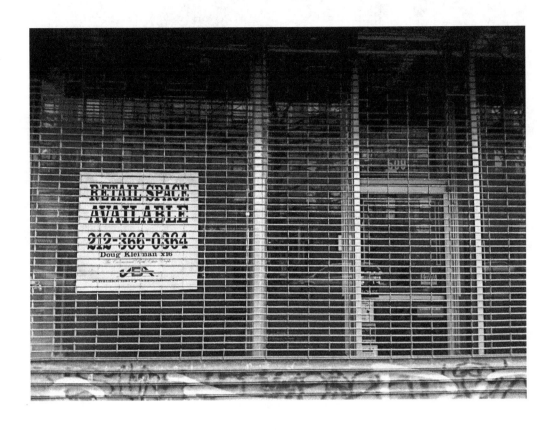

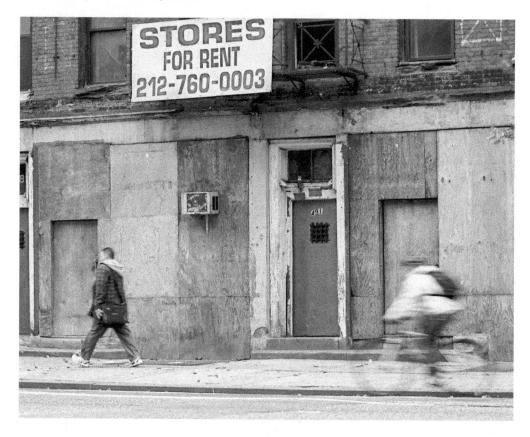

NEW YORK, NEW YORK, 2009

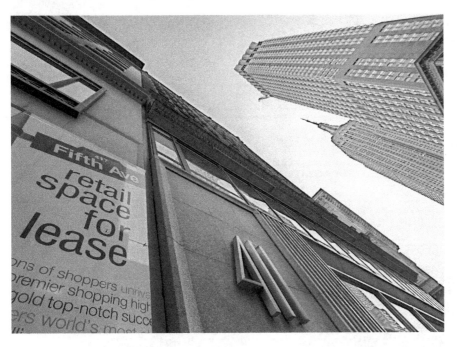

SAN DIEGO, CALIFORNIA, 2010

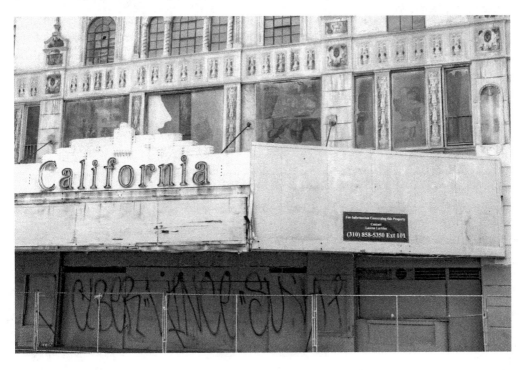

NEW YORK, NEW YORK, 2010

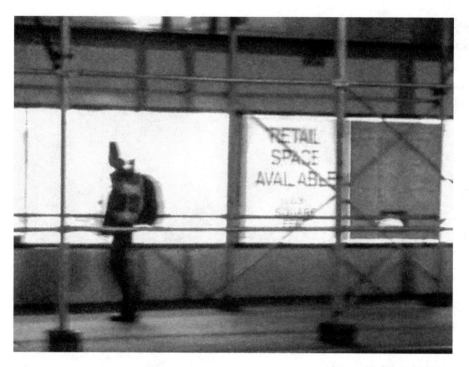

NEW YORK, NEW YORK, 2011

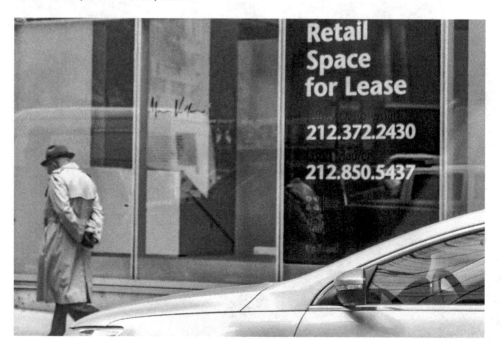

NEW YORK, NEW YORK, 2011

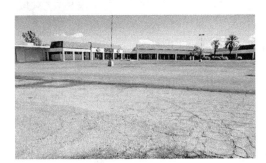

NEW YORK, NEW YORK, 2010

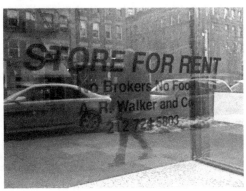

TUCSON, ARIZONA, 2010

TUCSON, ARIZONA, 2010

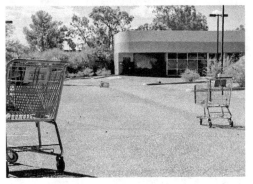

MONTGOMERY, NEW JERSEY, 2009

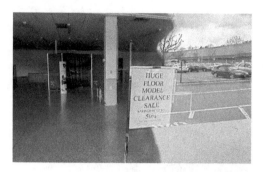

NEW YORK, NEW YORK, 2010

BOSTON, MASSACHUSETTS, 2010

ROUTE 1 CORRIDOR, NEAR TRENTON, NEW JERSEY, 2009

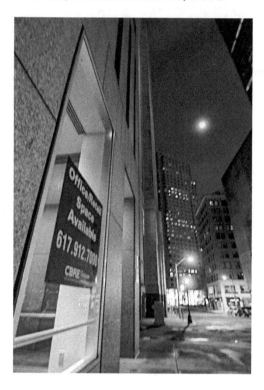

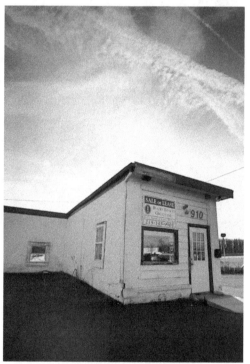

(Opposite, clockwise from upper left)
LOS ANGELES, CALIFORNIA, 2010; ROUTE 1 CORRIDOR, NEAR TRENTON, NEW JERSEY, 2009; SAN YSIDRO, CALIFORNIA, 2010; LA JOLLA, CALIFORNIA, 2010; SAN ANTONIO, TEXAS, 2009; NORTH BRUNSWICK, NEW JERSEY, 2009; ALLSTON, MASSACHUSETTS, 2010; PRINCETON, NEW JERSEY, 2009; BOULDER, COLORADO, 2011

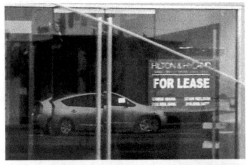

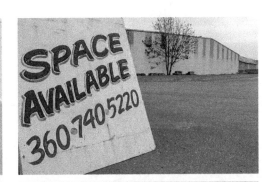

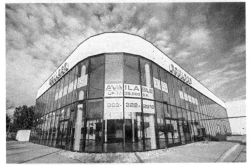

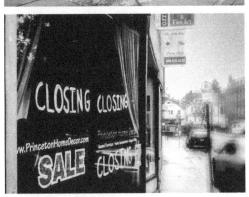

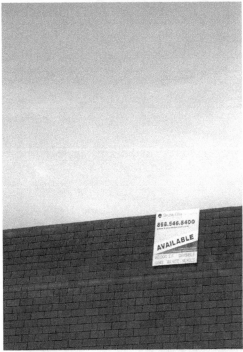

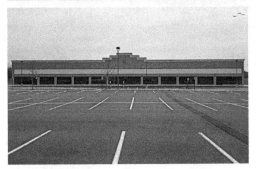

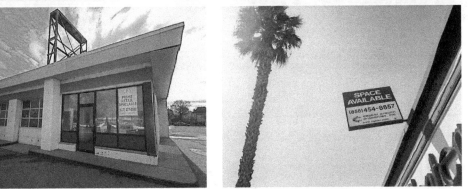

4

American
Studies Road
Trip

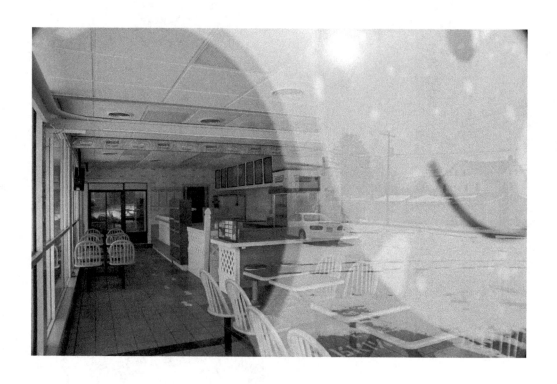

ALLENTOWN, PENNSYLVANIA, 2010

The camera loves a good juxtaposition. This smiley face surely made good sense to the person who painted it on this sunny diner window some years ago; but now, against a backdrop of desertion—business failed and the whole town seemingly crumbling all around—the familiar beaming smile comes across as nothing short of ghoulish.

Back to Dorothea Lange's proposition that the camera teaches us to see without a camera: here and elsewhere, whether in the stark ironies of juxtaposition or in the tiny details of somber beauty in a place like Allentown, what is actually documented in these photographs is not only the economic collapse of 2008 and after, but my own experience of learning to see. The camera mentors you in a kind of *noticing* that is crucial for a culture like ours, a culture whose claims are loud, whose pace is fast, and whose momentum continually jostles and buffets us away from quieter contemplations. *There is nothing to see here,* the culture seemed to be shouting, through all the calamities of the recession, like a cop on the street urging the traffic ever on past the scene of a horrific accident— *there's nothing to see here.* "Oh, but there is," the camera admonishes.[1] Such habits of attention, once learned, do not fade easily.

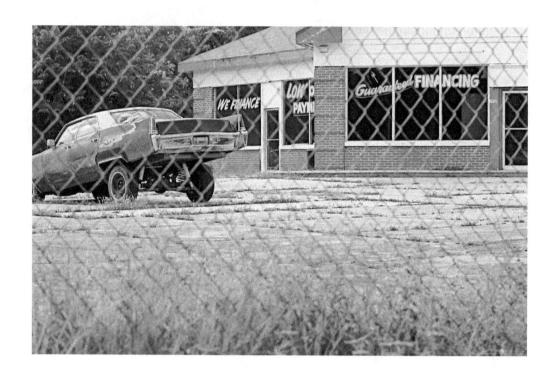

GAINESVILLE, FLORIDA, 2009

The entire arc of the American Century is here, rise and fall, from the optimism and boundlessness that conjured up heavily chromed, ten-mile-per-gallon family cars, to the global contraction that quickly made such highway boats a collector's novelty, to the hollowing out of the American Dream behind fine-sounding but finally false promises. The chain-link fence and thick overgrowth of neglect give the lie to an earlier day's blithe confidence in "guarantees."

When I returned to Gainesville in 2015, this lot was once again active. But in the fall of 2009 the desolate site and marooned hot rod summed up a local distress that was everywhere in view. Under the title "Aimless," an anonymous poet had posted a verse on the door of an abandoned store, grieving the town's buildings become "giant coral reefs." More than one person in the street declined to be interviewed unless I could pay them. I did interview a former union organizer who had worked for the Obama campaign. She described a recent job interview for the local gas company, which included a meter-reading footrace against competing applicants. Which, in its symbolic echoes of either *They Shoot Horses, Don't They?* or perhaps *The Hunger Games*, delivers us to a world at some remove, indeed, from the confident years that had produced this car.

NEW ORLEANS, LOUISIANA, 2010

The *Deepwater Horizon* exploded and sank on April 20, 2010, tragically killing eleven workers and leaving an uncapped pipe to spew oil into the Gulf of Mexico unchecked for almost four months. Between April and July, an estimated 210 million gallons escaped. Gleaming ribbons of oil streaked the surface of the Gulf; one could only guess what the plume looked like underneath. By early summer, the grim humor of anti-dispersant T-shirts and bumper stickers, "Don't 'sperse me, Bro," expressed a dawning popular awareness that the clean-up might actually be as hazardous as the spill. Although environmental impact was understandably foremost in people's minds, another set of equally portentous questions began to haunt the public discussion: in the showdown over responsibility and reparation, which would prove to be the more powerful body, British Petroleum or the United States of America, the multinational corporation or the nation-state? And did "the public good" have any standing at all in twenty-first century disputes of this kind? (The $18.7 billion that the Obama administration extracted from BP seems a minor miracle in retrospect.)

"What do they want, a world without oil?" I heard one passerby scoff at this anti-BP protest at the French Market one weekend that July. "I bet they drove here." The tight framing of this shot edits out what was one of the notable features of this demonstration, if you were there: the band of protesters was relatively small, and they were fighting an uphill battle to command the attention and understanding of passing tourists who had come to sample the Café du Monde's famous beignets. Editorial decision. What the severe cropping does succeed in conveying is the spirited theater and dogged political commitment of the event as staged, a living embodiment of Margaret Mead's famous dictum, "Never doubt that a small group of thoughtful, committed citizens can change the world. Indeed, it is the only thing that ever has."[2] This street demonstration—like the civic questions about our neoliberal world that rose as surely as an oil plume beneath the surface of public discussion—seems to me to presage some of the tenets and the tenacity of the Occupy movement fourteen months later, which is too often described as having burst out of nowhere.

NEAR GULFPORT, MISSISSIPPI, 2010

No one would have said that this is one of
the places where it was bad. No thick muck
on the beaches—no visible signs of loose
oil at all, actually; no befouled pelicans;
no Coast Guard officials and none of the
private security hired by BP to control the
flow of imagery and information. "It looks
like a military campaign," CNN's Wolf
Blitzer had said of parts of the Gulf region;
"heavy-lift helicopters taking sand to the
frontlines of the battle against the oil."[3]
But here it was quiet, almost peaceful.
Bright yellow sorbent booms floated use-
lessly here and there along the waterfront;
in some places they lay in tangled heaps on
the shore or right at the waterline, prob-
ably in bare, letter-of-the-law compliance
with some command specifying the distri-
bution of booms. When I opened the car
door, I was overtaken by the unmistakable
smell of petroleum, as strong as if I were
standing in the bay of a BP gas station. I
hadn't taken more than two or three steps
from the car before I saw the first dead
fish, of which there were many, it turns
out, fully visible without going any farther
than the shoulder of the road. But no one
would have said that this was one of the
places where it was bad.

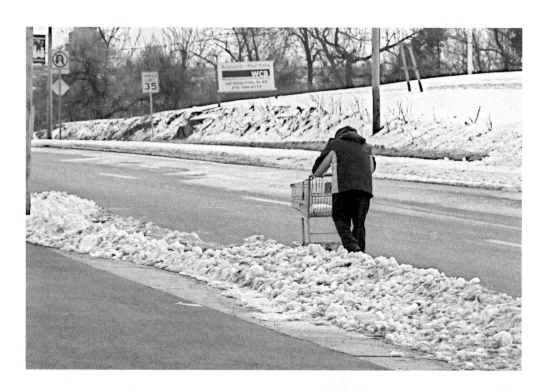

ALLENTOWN, PENNSYLVANIA, 2010

In certain places I visited, hardship and melancholy were everywhere to be seen. On this particular afternoon, I had just been photographing a demolition project, where a once-magnificent, World War II–era Allentown building was being torn down. At one time elegant and sleek, running two city blocks or more in length, the building now gaped open like a war ravaged body, its former symmetries disfigured by the violent amputations of wrecking ball, crane, and backhoe. I chanced to meet a contractor who was overseeing the destruction; he was open and quite talkative on the subjects of both his great fortune for full employment and his own profound sadness for the loss of this city landmark.

Moments later, and now standing a ways up the street, I watched this gentleman's long, slow slog up the hill, with one grocery item in his cart. I know nothing about him, and I did not interrupt his labors for an interview. Sometimes the camera documents, not a "fact," but a mood. I can attest: the affective scale of this image conveys exactly what Allentown felt like on this afternoon.

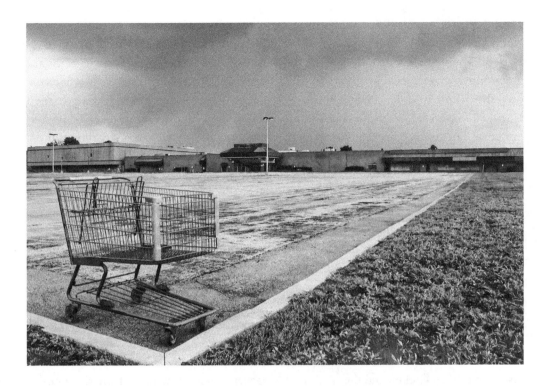

LEXINGTON, KENTUCKY, 2010

This particular shopping center was not a victim of the 2008 crash, but closed several years before. But it is the kind of landmark that has become more and more familiar in recent years—I have explored sites very much like it in New Orleans, Tucson, Trenton, Los Angeles, Brighton, Allentown, Binghamton, and New Haven.

Did I place the cart there, students in my Documentary Studies seminar wanted to know? No, as documentarian and historian, I would never do that—my inner compass insists on photographing the world exactly as found. I did walk the entire site—probably about eight or nine acres—in order to find the perfect angle on the abandoned structure, and I believe I found it. But the editing was something else again; photographs always lie, even as they tell the truth. Once the image was rendered in black and white, the asphalt on the lower left, the grass on the lower right, and the shadowed horizontal line of the building itself all came across in roughly the same shade of dark gray. When I adjusted the tones to accent the stark geometry of the image, the storm clouds also popped. I am confessing: the sky did not actually look this dramatic on that afternoon. So is this a lie? My documentary students' ethical sense was satisfied when I told them—and it's the truth—that, within about four minutes of taking this shot, I found myself standing in a downpour. Discuss.

TRENTON, NEW JERSEY, 2009

Not far from where I shot this shuttered plant on Route 1 outside Trenton, an enormous billboard for a local ice cream shop was advertising "Affordable Happiness, Next Exit." Interested in the juxtaposition of such a sign in this despondent setting, I pulled off the highway and wound my way back to the neighborhood where the billboard was located. As if placed by a mischievous poet, the iron stanchion of the "Affordable Happiness" billboard turned out to be sprouting from a lot behind the Trenton Area Soup Kitchen, a couple hundred feet from the highway. A small group of the soup kitchen's clientele eyed me warily from a doorway as I walked around back to inspect the sign.

This contrast between the crushing need of the soup kitchen and the "happiness" ad pitched at passing motorists is an apt metaphor for the rift that has been developing in the United States for decades and that the crash merely dramatized. Of course jarring contrasts of poverty amid abundance have existed for a long time — Stephen Crane made a living on such juxtapositions in his days as a city reporter over a century ago, and William Penn introduced the almshouse to North America about two centuries before that. But in the years since the 1970s, this gulf has become more deeply systemic *and* systemic in wholly new ways. Back in 1991, as the term *globalization* entered common usage, economist Robert Reich noted a certain "secession" of the well to do from the rest

of the nation. Rooted in the emergent realities of transnational labor frontiers, capital flight, and Reagan-era financialization (consider the incentive structure when corporate culture values stock prices over the sale of merchandise, for instance), "neither the profitability of a nation's corporations nor the success of its investors necessarily improve the standard of living of most of the nation's citizens. Corporations and investors now scour the world for profitable opportunities. They are becoming disconnected from their home nations."[4] This uncoupling may have begun with the fiscal severing of corporate profitability from local community; but it has grown to encompass a profound secession from the social fabric itself — private clubs, private schools, gated communities, privatized security, monies withheld from the common fund via rarified tax shelters and loopholes. We have become a "fly-over" culture, like the fly-overs of the highway system, whose blazing speeds and limited access render much of America not merely "optional" or easy to miss, but actually difficult to find and to see for those with the luxury of just breezing through. The billboard speaks of happiness to passersby, though firmly planted in the back lot of off-road misery. There is no longer much "common" in the "commonweal" — we have two economies, "prime" and "subprime" — as workers in this factory discovered in 2008.[5]

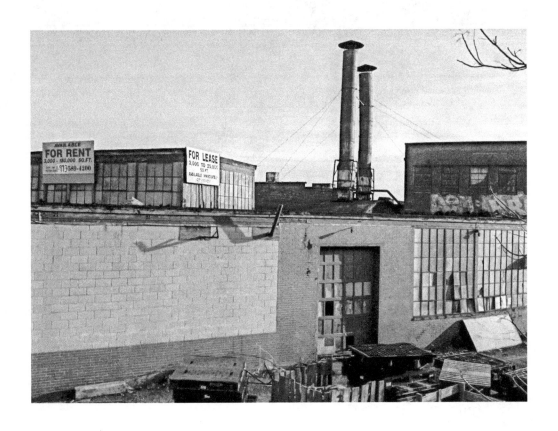

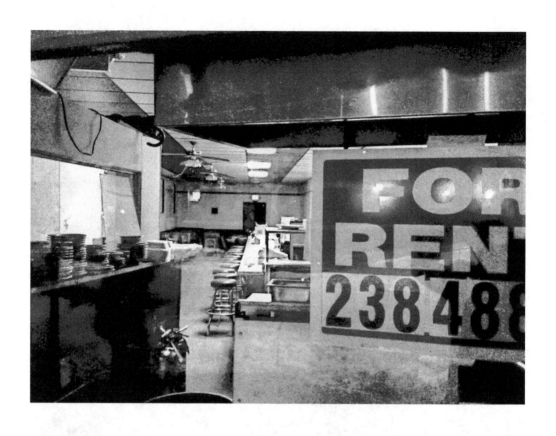

HARRISBURG, PENNSYLVANIA, 2010

Roving the desolate streets of Harrisburg late on a moonless, bone-chilling winter night, I came upon one of the project's more poignant sights. While in general the slow wreckage of the recession spread like molasses across the land, for some its devastation came rushing over the horizon in a flash. There was a ghost-town feel to this particular scene — dishes, pots, pans, furniture still in place behind the announcement of closure — as if line cooks, waiters, waitresses, and cashier had all fled in too much of a hurry to pack anything up or take anything with them.

"This place," a voice came from behind me as I peered through the window. I hadn't encountered anyone else on these streets for a couple of hours. Startled, I turned to see an older man in a plaid woolen jacket and earflap hat. "This place," he repeated, in a tone that conveyed both astonishment and melancholy, "I ate at this place yesterday." The two of us stood in a kind of reverent silence for several moments before he turned and continued on his way.

RURAL PENNSYLVANIA, NEAR ALLENTOWN, 2010

A plaintive cry in the middle of nowhere. Of course antiracism had been articulated as religious principle in both Old Testament and New: "You shall love the stranger, for you were once strangers in the land of Egypt" (Deuteronomy 10:19); "So Peter opened his mouth and said: 'Truly I understand that God shows no partiality, but in every nation anyone who fears Him and does what is right is acceptable to Him'" (Acts 10:34–35). But by the winter of 2010, about a year into the Obama presidency, it was impossible not to read such sentiments as pointed, topical commentary on the dire state of racialized relations in the United States. Not only did the 2008 election fail to deliver a "post-racial" nation; but racism seemed to be on the rise *because* of Obama's very success. "This president has exposed himself . . . as a guy, over and over again, who has a deep-seated hatred for white people, or white culture," railed Glenn Beck in mid-2009. Despite a fairly standard Democratic agenda, by this point in his young presidency *more* Americans thought Obama favored black people over white people than had thought so before the election. (More also believed he was he was an illegal Kenyan immigrant — by the end of 2009, only 21 percent of Fox News viewers believed Obama was American.) The public's racialized "reading" of the new president spilled over to affect almost any issue he touched — tax policy, health care, stimulus, environmental-

ism — there was no topic that did not mobilize racial resentments on one side and racial goodwill on the other. As researchers Michael Tesler and David Sears found, the polity thus quickly became more deeply polarized, not simply according to a political logic of red against blue, but simultaneously by an intensifying racial logic of white against nonwhite.[6]

I still find a certain charm in the impulse on someone's part to erect this sign out here along the rural highway. But in the context of the moment, I also understood this image as a visual metaphor for the banishment of the "post-racial." If a plea falls in the wilderness and there is no one there to hear it . . .

SAN ANTONIO, TEXAS, 2009

Paul Strand argued for a rigorous aesthetic sense in documentary photography. Though primarily a filmmaker, he served as an advisor to still photographers in the Photo League in the 1930s; and while many of his colleagues were wary of the "escapist" tendencies in artistic photography, Strand himself felt that aesthetic considerations had to be a central concern to the documentarian. Where photographers considered social subject matter alone, and paid little attention to formal elements such as composition and tonal scale, they produced images that "exhausted themselves on the first look."[7] The power of the photograph to instruct, he argued, depended on its power to arrest the eye.

But in ethical terms, what does it mean to render oppression or slow violence or economic distress as *beauty*—to find "beauty in all that injury and perplexity," as Robert Coles writes of the documentary pursuit?[8] Here one critical school might find a successful document of mid-crash melancholy on a San Antonio street—not "exhausted on the first look"—while another might question a certain fetishization of light and shadow, texture, and geometry to the detriment of social conscience. At the end of the day I arrived at what might not represent an ethical principle, but at least a philosophical one. The phrase "somber beauty" occurred to me again and again on my travels, and it appears more than once in my notes—meandering through the eerie quiet of downtown San Antonio, exploring a shuttered shopping center in Lexington, examining the ruins of Packard in Detroit or "the Steel" in Bethlehem, driving through a blizzard along foreclosure-wracked streets in eastern Pennsylvania. The social melancholy and mourning of these scenes—these sites' *affective scales*—were themselves fitting documentary subjects amid the crash. It wasn't the beauty of the photograph that drove me; it was the strange beauty of the *site*. But I do agree with Strand: the beauty does have a special power to express the sadness.

NEWARK, NEW JERSEY, 2012

In New Orleans I once saw the impos-
ing sight of a Katrina-ravaged home, that
immensely photogenic specimen of dis-
aster's aftermath, upon which someone
had scrawled in huge, spray-painted let-
ters across the exterior wall, "Don't take
pictures of my house!" I did not take the
shot; neither did I ever forget the ethi-
cal questions raised in that poignant piece
of graffiti. People now talk about "ruin
porn" or "disaster porn," a whole troubling
genre of photography that seems to make
sport of the cataclysms of a New Orleans
or a Detroit. Documentarians have long
struggled over the ethics of their work.
"When does honorable inquiry turn into an
exercise in manipulative self-interest," asks
Robert Coles, "even (that word of words!)
'exploitation'?"[9]

Coles was most concerned with the
human relationships between the docu-
mentarian and his or her informants —
between those who inhabit the conditions
under investigation (Appalachian poverty,
a war zone, a protracted miners' strike)
and the "social idealist" whose luxury it is
to gather material and then move on. But
he might have said the same of anguish's
infrastructure — a town or a street or an
abandoned building. The *porn* of "disaster
porn" does point up the ethical dimensions
of rendering a site of suffering for someone
else's cool contemplation in the comforts of
their own living room. I know exactly why
someone would write *Don't take pictures of
my house!* on the ruin of their home, that
is, and I know exactly why I honored that
request. Such questions should haunt all of
us, as practitioners and as reader-citizens. I
guess I am at peace with my own practices
because my historian's sense tells me —
taking the instance of Newark, here — that
if the society is in transit from one epoch
to the next, from the industrial to the de-
industrialized, it is best to travel that path
with as much consciousness as possible,
our collective attention focused on loss as
much as on possibility. For me, there is the
paradox: this kind of documentary work
may be inherently vulturous; but, ulti-
mately, so is it pastoral.

GAINESVILLE, FLORIDA, 2009

Juxtaposed with a 1959 Cadillac Fleetwood, this wry signboard (combining a derisive judgment on government inefficiency with a pointed wariness of government's tendency toward tyranny) exposes a fundamental divide in the American polity. The question of government's expense and its reach divides the electorate between those who see tyranny in every agency and program versus those who value the kinds of things that government does and that only government *can* do. This marquee traces its political genealogy from the "Don't Tread on Me" resentments of the Tea Party, back through Reaganomics ("Government is not the solution to our problem; government is the problem"), to Proposition 13 and the California tax revolt in 1978. From there, it is but a stone's throw to states' rights, which is undoubtedly why there should be such a furor over the role of government when an African American occupies the Oval Office. A campaign brochure for Barry Goldwater in 1964 had argued that the public accommodations clause of the civil rights bill could "open the door to a police-state system of enforcement that would eventually threaten the liberty of us all."[10]

The Cadillac, meanwhile, offers a quiet but hearty rebuttal. The year this car rolled off the assembly line in Detroit, the top marginal tax rate in the United States was 91 percent (compared to a mere 39.6 percent under Obama). The car was built at a time we rightly associate with tremendous

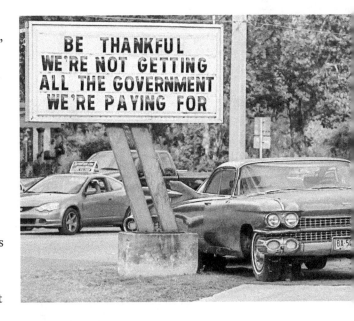

national prosperity—indeed, the Cadillac Fleetwood is one of American prosperity's gaudiest, most ostentatiously chromed and finned symbols—notwithstanding what some today would call the period's "job-killing" tax code. As he ran for president, railing against the "heavy hand of government," it was easy to forget that Mitt Romney himself had grown up in the household of an automobile magnate who was taxed at the 1950s' astronomical marginal rates. And yet Mitt grew up rich. And free.[11]

NEW YORK, NEW YORK, 2009

Free speech? A soapbox orator in Times Square preaches the gospel of universal health care, back when the Public Option was still on the table and arousing passions. In contrast to authoritarian societies, our problem historically tends to be less the *suppression* of speech than its fecund proliferation. With every surface inch of civic space up for sale to advertisers, a truly "public" or "civic" square is hard to come by, and today's orator has a steep climb. This poor fellow jostles for attention with a scantily clad woman bouncing on a trampoline on the two-story jumbotron in the background. She is selling—what, exactly? Distraction? The general pleasures of consumer capitalism? There is neither a brand nor even a particular product apparent in this majestic advertising board. In 2010 many would be up in arms for what the Supreme Court's *Citizens United* decision said about the voice of the ordinary citizen vis-a-vis the corporation in this democracy. But privatized public spaces like this one had long pointed up the unique vulnerabilities in our consumers' republic. Whereas *Citizens United* warns that all civic speech shall be monetized, our public culture instructs that whatever speech cannot be monetized shall be thoroughly overwhelmed. The triumphal product of late-century technologies of illumination, urban redevelopment ideals, commercial zoning ordinances, and a collective default ethic of commerce above all, the Times Square setting itself declares to orator and listener alike, "Say whatever you wish. Your 'free' speech will be rocked to sleep."

NEW YORK, NEW YORK, 2009

This acerbic piece of street commentary cuts to that zone where centuries-long tendencies in the development of a culture of consumption intersect with the distinct post-9/11 commercialization of grief and national mourning. A nineteenth-century New England farmer once wrote in his diary, "I never spent more than ten dollars a year, which was for salt, nails, and the like. Nothing to eat, drink, or wear was bought, as my farm produced it all." Decade by decade, telegraph lines, railroads, time clocks, wage work, factories, mass production, urbanization, advertising, and economies of scale swept people like him away from the moorings of a producerist way of life, and into the vortex of a consumers' republic, where one no longer met life's problems with the question "what should I do?" but instead, "what should I *buy?*"

On the day after 9/11, Walmart sold 116,000 American flags. They sold 250,000 the day after that.[12] But by the dawn of the twenty-first century, you could buy almost anything, it turns out. "In the weeks and months following 9/11," writes Dana Heller, "the market for goods representing American patriotic unity and pride expanded dramatically. American consumers both participated in, and bore witness to, a rapid transformation of the World Trade Center attacks into commodities aimed at repackaging turbulent and chaotic emotions, reducing them to a pious, quasi-religious nationalism." The website for the Ground Zero Museum Workshop (as they call it, avoiding the potentially distaste-ful use of the term "gift shop") advertises commemorative posters, prints, lapel pins, T-shirts, key chains, woven throws, bookmarks, tiles, magnets, plates, decorative pillows, totes, dog tags, jewelry, and jigsaw puzzles, all bearing the iconography of the Twin Towers' collapse. All, as Heller puts it, offering "the promise of closure through consumption."[13] We all remember George W. Bush's words to the nation in the wake of 9/11: "We cannot let the terrorists achieve the objective of frightening our nation to the point where we don't conduct business or people don't shop."[14] His defenders will say, what he meant was, don't let the terrorists keep you from going about your business; he did not literally tell us to "go shopping." But then, he scarcely needed to.

NOGALES, ARIZONA, 2010

Shortly after taking this shot, I was confronted by an officer of the United States Border Patrol who threatened to confiscate my camera and equipment. Certain aspects of the exchange are humorous, in retrospect.

BP: [Tapping at a holstered side arm] "Who are you working for?"

MFJ: "I'm just a tourist. I've never been to the border before—it's awesome."

BP: [Skeptically, perhaps sarcastically] "Nice gear, *Mr. Tourist.*"

But the humor is *only* in retrospect. Unlike a traffic stop or even an arrest by the police, there were no available scripts that I knew of for an encounter with the Border Patrol—no Miranda warning, for example, and no agreed-upon protocols for what might happen next. Could they indeed confiscate my photography equipment? Might they detain me? I noticed some specially designed Border Patrol trucks with cages on the back; are those for the officers' dogs, or for their captives? The accusation behind the officer's questioning was that, by photographing this site, I was "endangering" the Patrol. Was this a crime that I could be held for? The striking thing here was that I had every advantage that a person could possibly have in this situation: I was a U.S. citizen. I was white and male. I spoke English. I knew my rights. I had financial resources, and also intellectual and institutional ones—an immigra-

tion historian from Yale University surely has more capital at hand than your typical ICE detainee. *And I had not crossed the border*—I had broken no laws, and I had nothing to hide. So it was notable to me how much uncertainty and fear I suddenly felt, and how much cause this officer was giving me to be afraid (that weapon somehow remained very conspicuous through the whole exchange). I thought of the many millions—migrants and citizens alike—whose encounters with *la migra* are not softened by the advantages I enjoyed. Americans might really want to think about the power that is vested in the Border Patrol, and the daily, street-level disposition of that power. This is the thought that occurred to me, as I hastily packed up my gear and split.

PHOENIX, ARIZONA, 2010

Chinga la migra—"fuck the border patrol"—was a salient cry when I visited Arizona in 2010. Arizona SB 1070, the "papers please" law, had passed in April, requiring law enforcement officers to determine the citizenship status of any individual during routine policing encounters if "reasonable suspicion" (whatever that is) existed that the person might be undocumented. While the courts worked out the constitutionality of the bill (overturning parts of it in 2012), critics feared that it gave broad license for racial profiling and for harassment of Latino citizens and noncitizens alike. But there was already a long history to both the racial logic and the practices of harassment that it produced. As historian Kelly Lytle-Hernandez found, going all the way back to the 1920s (the Border Patrol was created in 1924), if officers some distance from the border did not actually witness crossings firsthand, "they used what the United States Supreme Court would later describe as 'Mexican appearance' as a measure for identifying unauthorized border crossers." As in, "I believe the two in that car are Mexicans, let us go and see if they are wet aliens." (This sentence is quoted in a 1929 memo from Acting Chief Patrol Inspector Chester C. Courtney.) That first generation of agents tended to use the words "American" and "white" interchangeably, and applied the term "Mexican" regardless of citizenship status—for them, there was never a presumption in favor of the Mexican-American.[15] *Chinga la migra*, then, gives name to a long-standing communal vulnerability that threatened to become deeper.

A month after the passage of this bill, protests against the Border Patrol became angrier still, when a two-and-a-half minute cell phone video went viral, showing three Border Patrol agents near the San Ysidro border-crossing beating and tasing a thirty-two-year-old migrant, Anastasio Hernandez-Rojas, until he lay lifeless on the ground. He can be heard on the video sobbing and begging for mercy. Humberto Navarrete, the man who shot the video, shouts, "Hey, he's not resisting," which fetches the cool reply from an onlooking Border Patrol officer, "He ain't cooperating." Hernandez-Rojas was at the time lying on his stomach with his hands cuffed behind his back as officers kicked and beat him, Rodney King–style. One of the officers waved the others away, and Navarrete "heard four, maybe six shots from the stun gun, and saw the victim's body convulse." Medics report that Hernandez-Rojas was brain dead when he arrived at the hospital; they took him off life support and pronounced him dead twelve hours later.[16] As human rights activists have argued, the U.S.-Mexico border is "where the constitution goes to die."

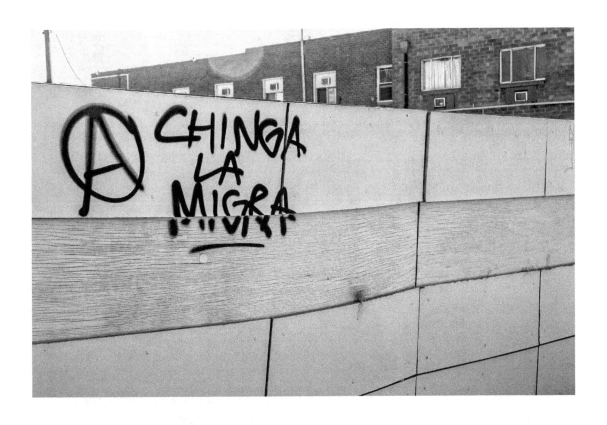

BOSTON, MASSACHUSETTS, 2011

The Dog Tag Garden Memorial in Boston's North End is a rare, vernacular monument to the soldiers lost in the U.S. wars in Iraq and Afghanistan (over 6,700 as of 2016). The United States went to war within weeks of the Al Qaeda attacks on 9/11, and has been at war ever since. But in truth the nation has been in a state of continuous war for much longer than that. Setting my own lifetime against the timelines of U.S. history: I was born when there were a bare handful of U.S. military advisors in Vietnam; by my second birthday there were significantly more. In kindergarten, a few years after the Bay of Pigs invasion and only about one year after the Cuban Missile Crisis, I experienced my first duck-and-cover drill (which my teacher Miss Roper implausibly called a "tornado drill"). The first U.S. search-and-destroy mission in Vietnam, Operation Hump just north of Bien Hoa, began on my seventh birthday (November 8, 1965), and I first registered the meaning of the term "body count" at about age ten. I graduated high school a year after the last desperate U.S. helicopter lifted off a Saigon rooftop; I was in college when the Iranian Revolution overthrew the U.S.-installed Shah; I decided to go to graduate school on the day the United States invaded Grenada; I carried out my graduate studies against the backdrop of the Salvadoran Civil War and the "covert" war in Nicaragua; I taught my first seminar on U.S. expansionism the semester that the United States invaded Panama; and I

finished my dissertation in the cold, late-night glow of televised reportage from the Gulf War. The years between then and 9/11 saw U.S. interventions in Kosovo, Somalia, Haiti, and Sudan, among others.

The U.S. military never did demobilize after World War II; the civilian population, on the other hand, did demobilize in stages — especially after the end of the draft in the Vietnam era — to the extreme extent that there are almost no signs on the home front that this is a country at war, and its war footing is a fact that has become shamefully easy for civilians to either disattend to or to forget altogether. Even the basically meaningless but once popular gesture of the yellow ribbon has become rare. The contemplative site of the Dog Tag Memorial at once disrupts and protests our inattentiveness.

5

I Want My
Country Back

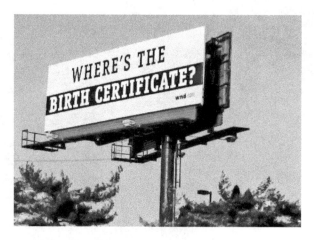

PHILADELPHIA, PENNSYLVANIA, 2009

The first church burning of the Obama era was on November 5, 2008, only hours after the election had been called in Obama's favor. In the wee hours after the election, three men doused the Macedonia Church of God in Christ in Springfield, Massachusetts, in gasoline and burnt it to the ground purely, as one of the convicted arsonists put it, "because it was a black church."[1] The next evening, on network television, a middle-aged, white woman in Missouri wept during a person-in-the-street interview, "I feel like I've lost my country." On the evening of Obama's inauguration in January, Frank Luntz called an urgent session at a Washington, D.C., restaurant, where a group of Republican dignitaries vowed to hold Obama's accomplishments as close as possible to zero. In the characterization of attendee Newt Gingrich, Republicans would combat Obama "on everything."[2]

Soon enough a full-blown politics of white displacement had taken shape, crystallizing in "birtherism" and WorldNet-Daily's well-financed intimations of usurpation, of which this billboard along the Pennsylvania Turnpike outside of Philadelphia is an instance. Obama, this argument went — a foreign national from Kenya, certainly a communist, and probably a secret Muslim — could not possibly be our rightful president. Whereas after Obama's election some were eager to tell a new, "postracial" story about an America without bigotry, one of the most powerful mainstream formations of white supremacy — or at least of white primacy — was quietly taking shape across a range of institutions and in response to a number of questions. Our national punditry had relatively little to say about this phenomenon *as a phenomenon* until the Donald Trump candidacy made it impossible to ignore. But by the time of Trump's famous escalator ride into the presidential contest in 2015, American political discourse on questions from immigration to terrorism to health care to urban policing had long betrayed a deep anxiety and misgiving about white displacement. Some of this had been brewing for decades, perhaps since Nixon's "silent majority," and certainly since politicians like California's Pete Wilson had fixated on the nation's long-term demographic shifts. But much of it, it seems, is just what you have to expect with an African American in the Oval Office.

BOULDER, COLORADO, 2009

This enterprising gentleman took his case to a street corner in the otherwise liberal bastion of Boulder, Colorado. One may have thought that, as a meaningful epithet in U.S. politics, the word *commie* had been relegated to the dustbin along with the Soviet Union itself. But on Obama's 2015 visit to China, even then-presidential candidate Ted Cruz would quip, "Media all across the world are reporting on this historic meeting of the world's most powerful communist — and the president of China."[3]

Historian Carol Anderson has summed up the furious anti-Obama backlash under the heading "How to Unelect a Black President."[4] Leaving aside the chimpanzee dolls at some Tea Party events or the internet memes depicting Obama in the stereotypical dress of a Hollywood witch doctor, "respectable" anti-Obama activity came to include insults hurled from the floor during a State of the Union Address; unceasing congressional efforts to grind government to a halt; purely symbolic votes serving no purpose other than to express condemnation of the president, including over sixty hollow votes to repeal the Affordable Care Act; an immediate spate of voter suppression laws across the states, meant to turn back future expressions of "black" public will, culminating in the Supreme Court's gutting of the 1965 Voting Rights Act in 2013, which in its turn allowed for a spate of new voter suppression laws in fourteen states[5]; and the Senate's unprecedented refusal to conduct confirmation hearings

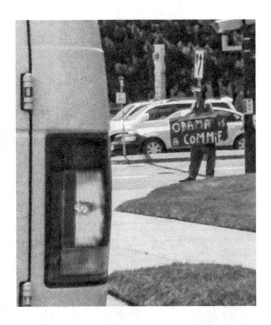

on a Supreme Court nominee, whom most admitted was in no way controversial and who had broad support across the aisle. Tea Party senator Jim DeMint once spoke of "breaking" Obama, a phrase that conjured for some the slave-holding past of his native South Carolina. "You hate Obama with a passion," wrote one *Daily Kos* blogger of Obama's tireless critics, even despite his centrism and his resemblance to a moderate Republican on many issues. "You call him a Kenyan. You call him a socialist. You dance with your hatred, singing it proudly in the rain like it was a 1950s musical."[6]

TUCSON, ARIZONA, 2010

The United States has spiked periodic fevers on the subject of immigration since the militarization of the U.S.-Mexican border in the late 1970s. The debate has typically unfolded on two distinct planes: an economic debate ("they" threaten to take "our" jobs), and a civic or social debate ("they" are inferior and unassimilable — precisely, it should be noted, as were the nineteenth-century Irish, Jewish, and Italian immigrants whose descendants now so comfortably constitute an American "we"). The emotive power of this debate was heightened in 2006, with the emergence of highly visible and vocal pro–immigrants' rights rallies across the country. But only upon the ascension of our first African American president did the anti-immigrant acrimony reach its highest pitch: *I want my country back* would seem to be a sen-

timent generated, not by actual immigration rates, but by Obama's blackness. Were one to gauge the present reality simply by listening to the chatter of the culture, one would never guess that immigration rates had declined significantly (having peaked in 2007) and that deportation rates had skyrocketed under Obama.[7] Rather, within a logic of white displacement that characterized the Obama years and reached new levels during the Trump campaign, the president was a "foreign" usurper and immigration itself, our most pressing and dangerous problem. In 2016 Trump connected the dots for us even more fully. But those patterns had already been structuring public discourse since 2009.

NEW YORK, NEW YORK, 2009

Overheard at a planning meeting for a Tea Party event in Boston: "The Obama Hitler sign. Let's look out for those people, and make sure people know, they're not us."[8] The "Obama Hitler" people were followers of Lyndon LaRouche, an odd, quixotic figure whose singular trajectory had taken him from the Socialist Workers Party, through an obsession with brainwashing and various conspiracy theories, and into alliance with Far Right groups like the Liberty Lobby and the Ku Klux Klan. LaRouche saw Obama's health-care reforms as a new iteration of Nazi euthanasia programs, hence the Hitler analogy (and the moustache). You can see why the Tea Party might want to distance itself.

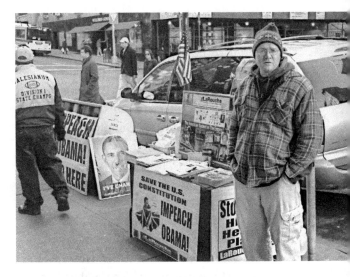

But to be fair, you can also see why an unenlightened person might mistake the one for the other: LaRouche's "Nazi euthanasia" argument sounded an awful lot like Sarah Palin's "death panels"; and both groups were early advocates of Obama's impeachment (the Tea Party enumerated ten counts to LaRouche's six).[9] As "fringe" as the "Obama Hitler" people might have seemed — even to Tea Partiers — the more salient thing to consider is how much they had in common with each other, and how much both of them had in common with respected members of the Republican Party. Between 2009 and 2013, party leaders like Darrell Issa, James Inhofe, Jason Chaffetz, and Tom Coburn also raised impeachment as a realistic possibility; and figures ranging from a state representative in Arizona, to country music singer Hank Williams Jr., to the Catholic Bishop of Peoria, to Home Depot founder Ken Langone all went on record comparing Obama to Hitler, as would Republican presidential candidates Rick Perry, Mike Huckabee, and Rand Paul.[10] It is hard not to think that at least some of this fury had to do with Obama's "presiding while black," as Michael Eric Dyson put it. "The far-right Tea Party and the conspiracy theorist birthers despise Obama so much that they want to banish him from Americanness," he wrote. "They want metaphoric sovereignty . . . over Obama's body: they want to unbirth his existence, uproot him from American soil, foreclose against his house of American identity. . . . Despite the claim of the right-wing that it is pro-life, it wants to retroactively abort Obama's existence, purge him from the record as unofficial and illegitimate, remove his legislation from the books, repeal 'Obamacare,' and wipe the record clean of his political speech."[11] On this, there was no daylight at all separating the "Obama Hitler" people, the Tea Party, the mainstream GOP, and — ultimately — the Donald Trump team.

ORACLE, ARIZONA, 2010

This small billboard, erected on private property on the outskirts of Tucson, stirred many layers of controversy in the fall of 2010. The message expressed something of the nativist mood in the context of Arizona SB 1070, the anti-immigrant legislation which Governor Jan Brewer had signed into law the previous April. But Sheriff Babeu (quoted on the sign) himself objected that the billboard was "offensive and misleading," its message undercutting "the great work our law enforcement members do on a daily basis to protect our Pinal County families." The "public safety threat" he had been referring to, he clarified, was not the everyday immigrant and certainly not the wholesome Latino family as depicted here, but drug traffickers and human smugglers only. He went on to add what he seemed to intend as a dig at Barack Obama, but what might be taken as a critique of the breadth of SB 1070 itself: "This billboard represents the same misleading and misguided message that President Obama made when he gave the example of how law enforcement would target a father walking down the street eating ice cream with his daughter if SB 1070 passed."[12] How would Arizonans adjudicate the question of what constituted "reasonable suspicion" of undocumented status, and finally of what constituted a public threat?

The story took one last turn, when it was discovered that the image on the billboard did not exactly speak to the "menace" of Mexico's border with Arizona, but actually depicted an Ecuadoran family at an immigrants' rights rally in Washington, D.C., on May Day 2009. The stock photograph, still available on ShutterStock.com under the search category "immigrant family," also showed up later on to illustrate a 2015 news story about Jeb Bush, Donald Trump, and the phenomenon of the "anchor baby."[13] Such is the politics of representation in this "nation of immigrants."

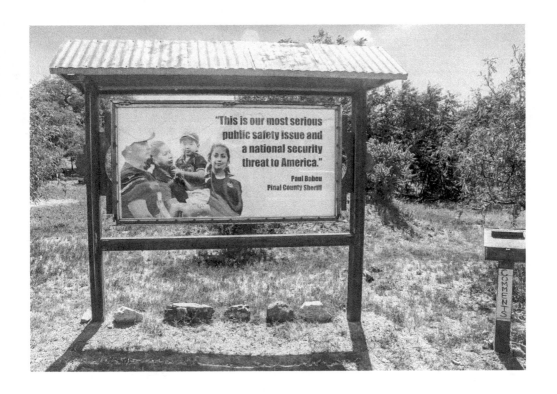

"This is our most serious
public safety issue and
a national security
threat to America."

Paul Babeu
Pinal County Sheriff

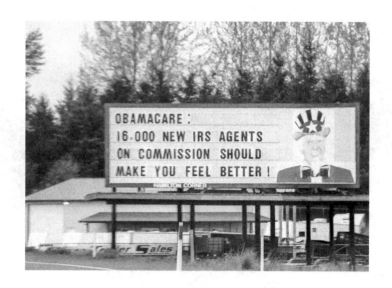

CHEHALIS, WASHINGTON, 2009

Conservative anti-Obama opinion was ubiquitous, varied, exceptionally loud, and also complex in its overlapping networks within months of his inauguration, from one-off protests like the "Uncle Sam billboard" along I-5 between Chehalis and Centralia, to a web of grassroots and corporate organizations going under the name of Tea Party, to the emergent Freedom Caucus in Congress, to "alt-right" (read: white nationalist) outfits like *Breitbart*, who excoriated Obama in 2009 for the "un-American premise" of his "extra-constitutional reign of political correctness, liberalism's brand of soft Sharia law."[14] The Tea Party was born exactly one month into the Obama presidency, though the focus of their purported concern — debt, spending, the size and scope of government — had been live questions since the USA PATRIOT Act. But on February 19, 2009, from the floor of the Chicago Mercantile Exchange, Rick Santelli put out the clarion call for some kind of a modern Boston Tea Party (protesting measures to "subsidize the losers' mortgages"), and the Obama administration was treated as an occupying foreign force ever after. *Don't tread on me.* Over 1,000 Tea Party groups appeared at the local level across the country, soon buttressed (though never completely controlled) by the Koch brothers, Dick Armey, Sarah Palin, and other national figures, who launched big-money efforts like FreedomWorks, Tea Party Express, and Tea Party Patriots. At the outer edge were groups like the Oath Keepers, who prepared for Obama's inevitable declaration of martial law, and Tea Party Nation, which the Southern Poverty Law Center (SPLC) categorized as a hate group. As one Tea Party participant in Virginia put it, patriots like him felt that they were "losing the nation they love, the country they planned to leave to their children and grandchildren."[15]

This is a motley grouping, and distinct conservative publics surely differed in many ways; but it is difficult to imagine that Obama's blackness was entirely incidental to any of them. Some Tea Party participants left little doubt, waving protest signs that equated Obama's presidency to "white slavery" or likened safety-net programs to a "plantation mentality"; one ex-policeman remarked frankly, "The people I was looking for back when I was a cop are now running the government." Researchers Theda Skocpol and Vanessa Williamson summed up one Maine meeting's consensus view of the Democratic Party as "an unholy alliance of dependents on 'welfare,' public sector employees leeching from taxpayers, and immigrants trying to vote illegally."[16] Such ideas had festered on the American Right for many decades, but in 2009 Obama became their irresistible — and heavily racialized — symbol.

PHILADELPHIA, PENNSYLVANIA, 2010

"It is okay to be white and angry," writes Michael Eric Dyson; "it is not okay to be black and angry."[17] Hence the white rebuttal to Black Lives Matter: "*All* lives matter—shut up!" One of the striking features of U.S. political life in the Obama years was the constant and unyielding expression of white anger—the Tea Party, Fox News shouters like Sean Hannity and Glenn Beck, obstructionists in Congress, the Freedom Caucus, Sarah Palin's book tours and "open carry" gun rallies, the rising white nationalist movement (the SPLC charted the rise of "militia groups" in the United States from 149 to 1,360 over Obama's first term[18]), all hurdling toward Donald Trump's frenzied worry over immigration and the Muslim presence. ("If nothing else, the election [of Obama] has harassed white people to death," Fred Moten laughed when we spoke in 2012; "they're just fit to be tied. I tip my hat to it on that level."[19]) All this white anger despite the fact that statistics on most anything you can think of—the distribution of wealth, unemployment rates, housing practices, vital statistics like life expectancy and infant mortality, the quality of education, prevailing practices in policing and sentencing, voting rights, media representations and stereotypes, the distribution across neighborhoods of bad things like toxic waste dumps and good things like grocery stores—pick your metric, indicate that white privilege is unquestionably "a thing." The signage on this Philadelphia diner knits together centuries-deep expressions of xenophobia, nativism, racism, and jingoism for the pointed Obama moment. The *back* of "I'm mad as hell and I want my country *back*" does raise a question—back from *who*? But you know who.

This is deeper than bigotry—deeper, in some ways, even than hatred. "It wasn't the whiteness of the Tea Party that I found most striking," writes historian Jill Lepore. "It was the whiteness of their Revolution . . . [the] fantasy of an America before race, *without* race. There were very few black people in the Tea Party, but there were no black people at all in the Tea Party's eighteenth century. . . . There were only the Founding Fathers with their white wigs, wearing their three-cornered hats, in their Christian nation, revolting against taxes, and defending their right to bear arms."[20] The racism that characterized American political discourse in the Obama years was not generally a language of outright bigotry, though there was some of that. More profoundly and more pervasively, it was a language of white *primacy*—that preconscious but powerful sense of white normalcy and entitlement (and hence of displacement) that is highlighted in the observation, "When you're accustomed to privilege, equality feels like oppression." On the Far Right, Lepore later concluded, "It's not the past that's a foreign country. It's the present."[21]

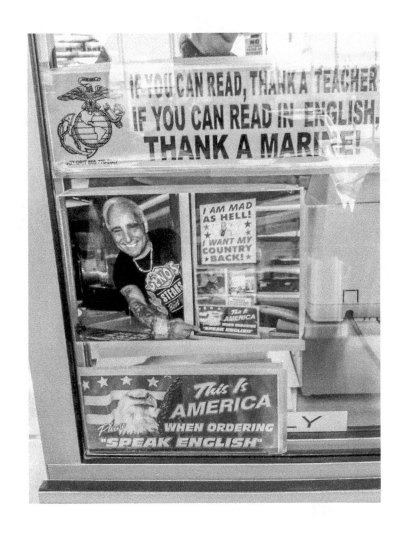

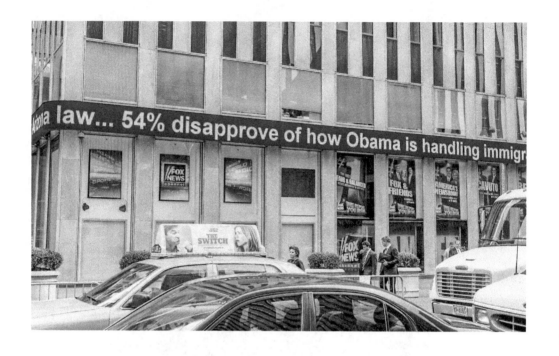

NEW YORK, NEW YORK, 2011

A private security guard stopped me while I was trying to photograph the Fox News building—one of those full-on, palm-covering-the-lens moves: *No cameras here, Bub.* We were standing on a New York City sidewalk at the time. This longer shot from across the street is better anyway; but the encounter does get you thinking.

U.S. civic discourse took a bad turn when the advent of the coaxial cable remade the world of three networks into a world of many more in the early 1980s—10, 25, 150, and later upwards of 500 cable channels. More bandwidth and more information might seem a good thing; but the discordant, competing, boutiqued "realities" of narrowcasting turn out to create problems wholly unknown to the "manufactured consent" era of CBS, NBC, and ABC.[22] As a segmented, market-niched populace, we found ourselves hived off from our neighbors and daily exposed not only to divergent lines of inquiry but to wildly diverging data sets on basic facts. Our civic discourse took a second bad turn when Fox News emerged as one of these many new networks. Roger Ailes once predicted that television would functionally replace the political parties over time; by the Ailes era at Fox (1996–2016), that "fair and balanced" network was but a mouthpiece for the Republican Party, self-appointed to counter mainstream (read: liberal) "misinformation." Fox has functioned as the lifeblood of American conservatism, perhaps, uniting many diverse Tea Party, FreedomWorks, Freedom Caucus, Heritage Foundation, *National Review*, and alt-right publics; but it has proved pure poison for the body politic at large, cultivating a huge swath of dead certainty about things that are just not true.[23]

Opinions and interpretations might be reasonably debated; but alternative "facts" are more tenacious. I was raised during the Cold War, and I was educated to discern and despise this media method and the impulses behind it: they are *Soviet.*

NEW YORK, NEW YORK, 2010

Rick Lazio, mobbed by the press here, was a one-issue gubernatorial candidate whose 2010 campaign rested largely on challenging Imam Feisal Abdul Rauf's right to build an Islamic community center at 49–51 Park Place in lower Manhattan. Such a center would be a threat to New Yorkers' "personal security and safety," he argued.[24] This was the famed "Ground Zero Mosque," though it was neither at Ground Zero nor, in fact, a mosque. Having tripped over the obvious constitutional problems with condemning the center on religious grounds, opponents tried claiming that the imam's proposal would entail the demolition of an important historic building—"a fine example of the Italian Renaissance-inspired *palazzi*."[25] The Landmarks Preservation Commission belly laughed. The building, a Burlington Coat Factory, was no architectural treasure; opponents of the imam's project were going to have to find someone else to do their dirty work.

I took this shot of the press frenzy around Lazio at the hearing where that decision was announced. What struck me at the time was how much attention Lazio and the other opponents were drawing. The general sense of the hundred or so people in the room when the decision came down was a giant collective sigh of relief—the proper decision had been reached. A tiny handful of people objected—Lazio was one, I recognized Far Right blogger Pamela Geller as another, and there were maybe two or three others. Some of them shouted "shame, shame, shame" at members of the Landmarks Commission, but they were in a very tiny minority. And yet the press seemed interested in them, and in them alone. What later struck me was the profound effect that this coverage had on public discourse. Within days the phrase "Ground Zero Mosque" was on everybody's lips; Newt Gingrich was warning that Islam posed "a mortal threat to freedom"; and anti-Muslim protests were being reported across the country.[26] Later that fall I interviewed Daisy Khan, Imam Abdul Rauf's wife and his spiritual partner in the Park51 Islamic center project. She spoke with great poignancy about life in the media funhouse. Groups like Jihad Watch and Geller's Stop Islamization of America had made megaphones of outlets like the *New York Post* and Fox News—"they became full-time dedicated to it. . . . They became stars," she said. The media were "continuing to promote this almost grotesque image of us. We couldn't even recognize ourselves after a while. I would be afraid to turn on the TV because I'm like, oh my God! That's me? That can't be me. Are you talking about me?" Even in the immediate aftermath of 9/11, Khan observed, "we [Muslims] didn't have this kind of vitriol."

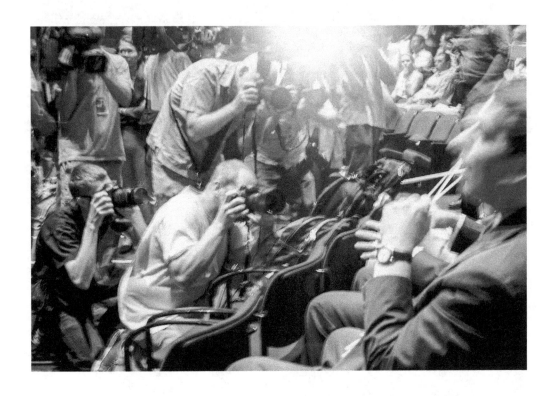

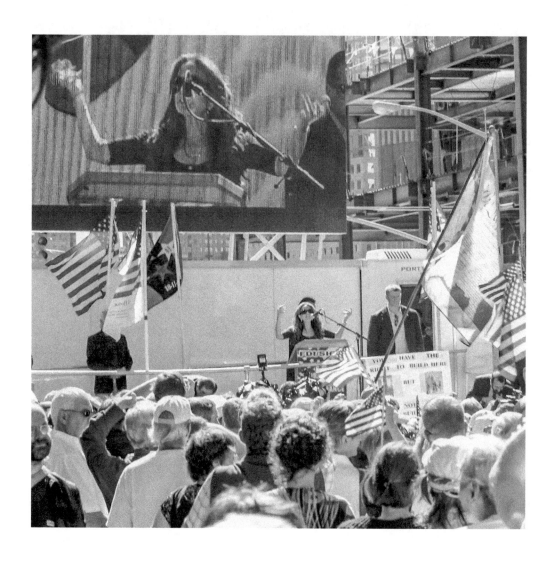

NEW YORK, NEW YORK, 2010

With the help of a symbiotic press corps, Pamela Geller leveraged the "Ground Zero Mosque" issue into fame and following. A former *New York Observer* associate publisher, Geller became a full-time anti-Islamic alarmist in the wake of 9/11, especially vocal after Obama's election. "Hussein [Obama] is a muhammadan [*sic*]. . . . He wants jihad to win," she warned on her blog, Atlas Shrugs. "Obama is a third-worlder and a coward. He will do nothing but beat up on our friends to appease his Islamic overlords."[27] Her notoriety crested around the time of the Park51 controversy, but she has never let up on this linkage between the evils of Islam and the evils of Obama: "It's a pity that the first African American president wasn't someone who was noble and American and patriotic," she lamented in 2015, but he instead turned out to be "this usurper, this interloper, this fraud." When Obama referred to ISIS as *Daesh* for strategic rhetorical reasons in 2015, she objected, "Well, excuse me, Mr. President, but we speak American here."[28]

When people like Geller tell us that their hatred of Islam and their hatred of Obama are conjoined, we ought to listen. A piece of vitriolic hate mail received in the Harlem offices of the Center for American Islamic Relations in 2010 opens, "Greetings you pigfucking sandnigger," and closes, "PS: Hussein obama [*sic*] is nothing more than an ugly fucking muslim nigger." Others referred to Park51 as "the Obama mosque."[29] There are many metrics for measuring a phenomenon as diffuse and multidimensional as Islamophobia over time; none of them is entirely conclusive, but most of them do indicate a counterintuitive rise in American Islamophobia *years after* 9/11, during the Obama years. Polls found that 39 percent of Americans held unfavorable views of Islam as a whole in 2001; that number was up to 55 percent in 2010. Hate crimes against Muslims were higher in 2010 than in any year since 2001; conflicts over mosques (efforts to prevent the construction of a mosque or violent attacks against them) rose sharply from 9 (2005–2007), to 20 (2008–2010), to 89 (2010–2012). A number of "anti-Sharia" bills passed state legislatures, beginning with Oklahoma in 2010.[30] One forgets that soon after 9/11, while Ground Zero still smoldered, George W. Bush addressed the American Muslim community in broadly ecumenical—and in retrospect, astonishingly evenhanded—tones: "We respect your faith. It's practiced freely by many millions of Americans, and by millions more in countries that America counts as friends. Its teachings are good and peaceful, and those who commit evil in the name of Allah blaspheme the name of Allah. The terrorists are traitors to their own faith, trying, in effect, to hijack Islam itself. The enemy of America is not our many Muslim friends."[31] It is inconceivable that Barack Obama could say such a thing without stirring violent hatreds and suspicions. (I can't footnote this, for lack of space. Clear a few weeks in your schedule, and Google "Obama pro-Muslim.")

NEW YORK, NEW YORK, 2010

"The gaze of the witness and that of the voyeur are not the same," writes photographer Ken Light.[32] I weighed this question of the gaze every day of this project. The idea of "witness" is important, but there is more. What does it mean to do *historians'* work with a camera? I can never tell whether the images I shot were substantively different from those of the journalists I shared the streets with. Did I scout an event differently? Do the historian's concerns translate into distinctive angles and images at an event like Pamela Geller's anti-Islamic rally in Manhattan? Ultimately I can't separate my photographs, as documents, from my own questions as I shot them or my own historical associations as I view them. I know that my motive was not to "tell a story," as a journalist might, but to document a social condition. I went to Ground Zero on this September afternoon, not to capture the spectacle of a single rally on a single day; I went out of a historian's sense that Geller's anti-Islamic congregation was like a geyser, its hatred and its ideas heaving from some broad, deep volcanic substrate in the political culture. My interest was less in the spectacle of the eruption than in the hydrogeological conditions deep beneath. Camera in hand, I was working the same area of my brain that I worked when I wrote books about race, immigration, empire, white supremacism.

An intrepid counterdemonstrator wearing a T-shirt featuring Barack, Michelle, Malia, and Sasha Obama, taunted the madding crowd: "O-bam-a, O-bam-a, O-bam-a!" he chanted. Some returned jeers. "You're just pissed," he shouted, "that a black man is in the White House. Go home! You lose!" Which reminded me of one of the very first things I had ever read in grad school: "The modern right wing feels dispossessed: America has been taken away from them and their kind, though they are determined to try to repossess it and to prevent the final act of subversion. The old American virtues have already been eaten away by cosmopolitans and intellectuals; the old competitive capitalism has been gradually undermined by socialist and communist schemers; the old national security and independence have been destroyed by treasonous plots, having as their most powerful agents not merely outsiders and foreigners but major statesmen seated at the very centers of American power." Richard Hofstadter wrote this—the perfect caption to this festival of hatred at Ground Zero—in his essay "The Paranoid Style in American Politics" in 1964.[33] Substrates, hydrogeological conditions. Is the camera adequate to record them?

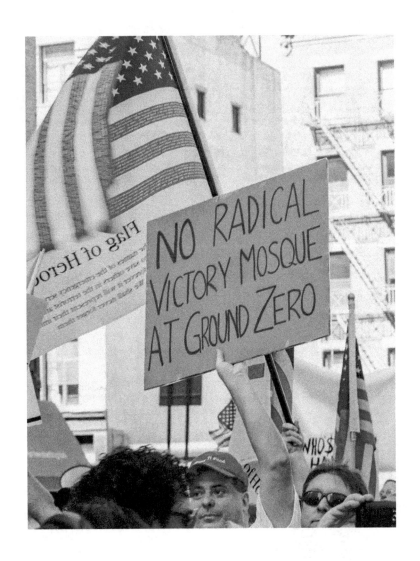

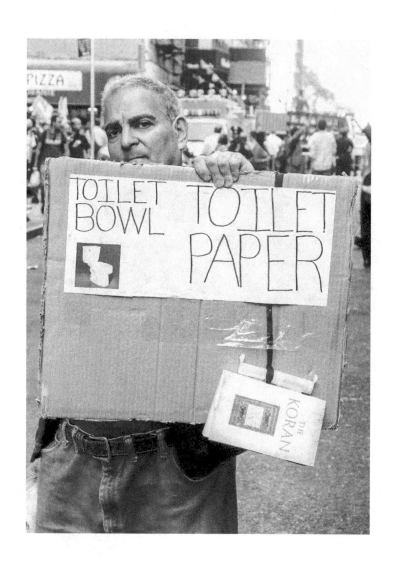

NEW YORK, NEW YORK, 2010

One can read the historically accrued layers of anti-Muslim sentiment in the United States the way an arborist reads the concentric rings in the cross section of a tree trunk. At the very core is a robust Christian hegemony—written into the colonial charters and influencing the post-Revolutionary culture even despite the Founders' commitment to religious freedom. "America is a Christian country," we hear again and again, even now. The next ring is a profound nineteenth-century belief that, as Orientalist scholar Lord Cromer wrote, the Middle Easterner "generally acts, speaks, and thinks in a manner exactly opposite to the European"—thus the need for wariness, and for Western "expertise" in interpreting behavior in this part of the world.[34] This core Orientalist presumption still sends "experts" like Bernard Lewis to the writings of eighth-century Islamic clerics in Kufa in order to interpret twenty-first-century events in Manhattan or San Bernardino. (Contrast this with the way Americans extracted Catholicism from the equation, at times, of rampant Irish terrorism, for example.) The next concentric ring is the relatively recent invention of a "Judeo-Christian tradition" that supposedly guides both religious and secular life in the United States. The concept first appeared in theological discourse only in the nineteenth century, and was not part of the popular American lexicon until the 1940s. After the Holocaust, "Judeo-Christian" became a civic term of ecumenism that still drew a sharp border at the edge of the so-called Orient. Sociological tracts like *Protestant—Catholic—*

Jew and Hollywood spectacles like *Quo Vadis?* and *The Ten Commandments* told us who we were as a nation. American reaction to the Six Day War (1967) begins a transit to the next era, resting squarely on "Judeo-Christian" affinities but also pointing toward the ideology by which Americans would comprehend the Munich massacre (1972) and Iranian Revolution (1979). The latter decades of the twentieth century introduced "Nuke 'em til They Glow" bumper stickers and films like *Black Sunday*, cementing vernacular ideas about a sui generis "Islamic violence" deriving from Quranic teachings rather than from political economy, colonialism, or history. The last concentric rings are perhaps most readily apparent: the post-9/11 period of perpetual warfare (a company called Brick-Arms now markets a Lego-compatible toy terrorist who is legibly Islamic); and the post-2009 period, in which a "secret Muslim" usurped the White House. It is the full fury of all of these distinct but accrued historical formations together—Christian hegemony, Orientalism, the prior right of "Judeo-Christians," hatred of the PLO and the Ayatollah, fear of asymmetrical warfare, and Obama-era grievances of white/Christian displacement—that took to the streets around the Park51 controversy and that filled arenas around the country to applaud a ban on Islam during the first season of Trumpism.

NEW YORK, NEW YORK, 2010

Patricia Williams recalls a time riding on a train: "[I] languidly fell into overhearing the conversation of a very well-dressed, well-educated family seated across the aisle from me. Here was a family with traditional values *and* Ralph Lauren looks." Soon, amid the hearth-like glow of warmth in this circle, the family took to telling hateful jokes—in this instance, not racist jokes, but "redneck" jokes. "What's a redneck?" the little girl asked. The innocent question did not have the effect of "drawing these otherwise thoughtful adults up short in a lifeboat of glorious contrition and renewed sense of social awareness"; rather, they initiated the girl in the ways of "redneck" derision—providing both definition and more specimen jokes—to the extent that the child herself could gleefully join in. "Hate learned in a context of love is a complicated phenomenon," Williams remarks. "And love learned in a context of hate endangers all our family."[35]

I have thought about this passage many times in the context of this anti-Islamic rally in New York, the most hate-drenched place I have ever been. At times I've reflected, I saw no children at this event—perhaps there is some hope that this kind of hatred will hit a generational dead end. I have no sociological explanation for the absence of children here; it's just an observation. But I tend to doubt the generational dead end theory of Islamophobia in the United States. Unlike generic racism or homophobia—which are unquestionably robust and persistent, but which do seem to have generational valences in certain regions—Islamophobia has become too normalized, too openly spoken, and too acceptable in our political culture to be vanquished very easily. In the post-9/11 era Islamophobia often registers as a concern for "our troops" abroad and a fear for one's own life here at home in a way that is too plausibly realistic to too many people for banishment from even polite discussion. Marwa Eltagouri recalls the classmate who approached her at the pencil sharpener in the days after 9/11 and casually asked, "Do your parents teach you to kill people because you're Muslim?" "*What?*" she said. "No, that's the most evil thing you can do!" "Nope," the boy replied, "my mom said you guys blow buildings up."[36]

What lessons about the world are learned in the loving embrace of an elder wearing a "Waterboarding Instructor" T-shirt? And can such lessons be unlearned? I can't help thinking about the child who gets that Lego-compatible toy terrorist for Christmas from a favorite uncle.

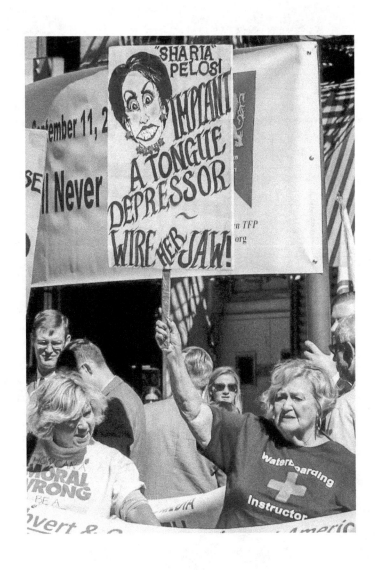

6

Reflections

SEATTLE, WASHINGTON, 2009

I took a shot of this garage in Seattle with my cell phone on the spur of the moment. At the time, the thing that struck me was the seeming desecration of an object that would have been almost sacred six months before. Or *fully* sacred. This was summer 2009, and as I looked upon this discarded placard amid the other detritus and rubbish, I could still hear and feel the awed, reverential hush on the National Mall at the first inauguration—I could hear the voice of a former graduate student, an African American anthropologist, who had told me that witnessing Obama's inauguration had been the very best day of her life, "even better than my wedding day." She had meant that; and I understood it.

The photograph still summons a vague sense of sacrilege for me, in the context of its own moment; but the elapsed years have added other layers of meaning as well. As the 2012 election approached, I would look at this image and think, "I hope this doesn't turn out to be an apt symbol of the Obama presidency." Later on still, amid thundering Republican promises to roll back Obama's every accomplishment, I would think, "I hope this doesn't turn out to be symbolic of the Obama legacy." But by now I've come to look at it both more literally and more philosophically as the thing it probably always was: it's not about Obama at all, but about the relentless press of quotidian life and necessity against the paroxysms of history that grip us. Novelist Milan Kundera tells the story of a Czech woman whose neighbors have promised to help her harvest her pears on what turns out to be the day that Russia invades their country. Crazily, she is terribly upset when none of them shows up. But who can argue? "Are tanks really more important than pears?" the woman's son reflects. He begins to feel "a secret sympathy for Mama's perspective, which had a big pear tree in the foreground and somewhere in the distance a tank no bigger than a ladybug, ready at any moment to fly away out of sight. Ah yes! In reality it's Mama who is right: tanks are perishable, pears are eternal."[1] So now the forgotten placard speaks to me of life's "pear-ness"—kids have to be packed off to school every day, bills have to be paid, dog has to be walked . . . The kind of pear-ness that can make collective political and social commitments hard to sustain, to be sure, but also the pear-ness that allows for curative rhythms—like harvests—and for love close up.

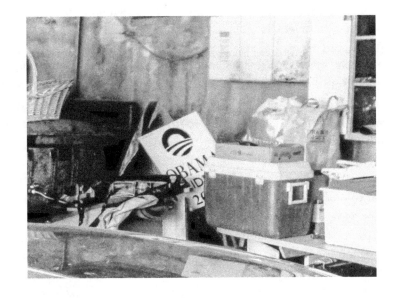

NEW YORK, NEW YORK, 2010

I met this couple at Pamela Geller's anti-Islamic rally near Ground Zero on September 11, 2010. Like me, they had slipped down this side street to get a respite from the vitriolic poison of the event itself. It is of course the woman's placard that will draw your attention; but, back in the shadows, the poignancy of the photograph, to me, is in the patent melancholy on her partner's face. This demonstration was a very, very difficult place to be.

As a historian, I suppose, in one way or another I have been grappling my entire career with her poster's assertion. Seemingly against the odds, it is true; American intellectual currents have steadily turned up the likes of Frederick Douglass, Lydia Maria Child, Sojourner Truth, Dorothy Day, Carey McWilliams, Carlos Bulosan, Martin Luther King, Jr., Bobby Kennedy, Abraham Heschel, Gloria Anzaldúa, Grace Lee Boggs, June Jordan, John Lewis. . . America has reared generations of peace activists and prophets of social justice and nonviolence; we have witnessed myriad noble acts of truth-telling, succor, generosity, coalition-building, empathy, and love. But the annals of American history are strewn with hatreds, too. American traditions — some embraced by national actors whom we continue to glorify — gave us Indian wars, slavery, the Trail of Tears, Manifest Destiny, anti-Catholic political parties and anti-Mormon violence, the *Dred Scott* decision, the Black Codes and Jim Crow, the Chinese Exclusion Act, lynching, nativism, territorial conquests, anti-Jewish quotas, Japanese-American internment, the military-industrial complex, homophobic ordinances and street violence, racial profiling, anti-"Sharia" hysteria, church burnings, mass deportation, mass incarceration, mass shootings. If you ever care to see just how closely mainstream conceptions of American progress, nobility, and heroism can be entwined with outright, full-throated hatred, take a look at Teddy Roosevelt's *Winning of the West*. Hate is not an American value? I have to answer, if I'm honest, that the verdict is still out on that one, that it strikes me as more aspirational than factual. But it is a worthy aspiration, and there is much in our intellectual and moral inheritance, from Lydia Maria Child to John Lewis, to light us the way. The best each of us can offer — the very least we *must* do, the very most we *can* do — is to fight our hardest to make this slogan so.

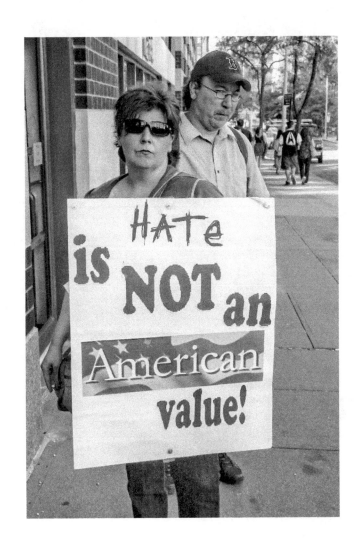

NEW YORK, NEW YORK, 2010

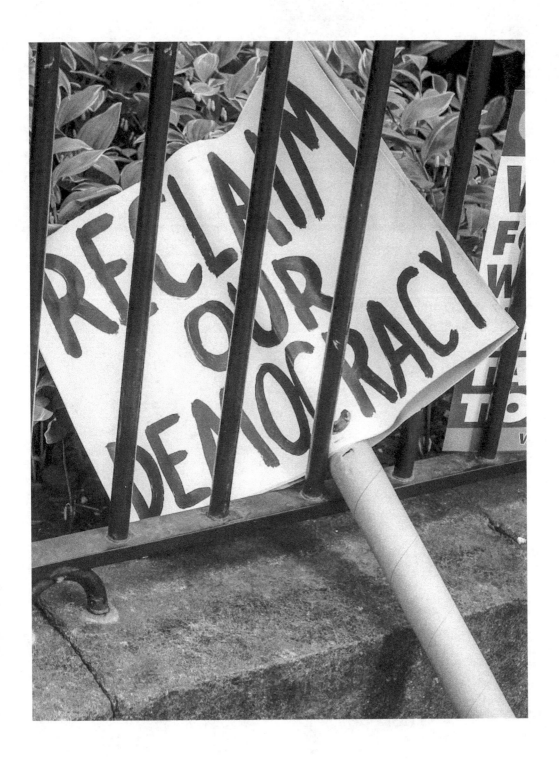

Afterword

ONE LAST MEDITATION (2017)

Can the camera serve as an historian's instrument? This is the question that drove my experimental fieldwork beginning in 2009, and it is the question that both dogged and transformed each phase of my thinking as the work developed into a web-based documentary (2010–2014), a gallery installation (2014), and finally a book manuscript (2016). The archive I was assembling, it turns out, documents as plain as day the rise of what we now know as Trumpism. This was not clear to me at the time, though it did come increasingly into view as Trump himself came over the political horizon in the latter half of 2015. There was no going back to revise this work after election night, though November 8, 2016, did seem to alter the meaning of every word and every image here, just as surely as it changed our political world. It was not a difficult decision for me in the days after the election to just let this project stand as it was, a bug in amber from a previous epoch. All of the photographs reproduced here were taken between 2009 and 2014; all of the writing was done in the spring and summer of 2016, completed by early October in a state of semi-certainty that the Trump campaign would be relegated to the trash bin, but also dead sure that certain documented undercurrents of conflict, despair, white rage, and hatred needed to be acknowledged.

The "historian's instrument" in this in-

stance accomplished more work than the historian himself knew. Trump is a flamboyant autocrat, and there is indeed some sense in talking about the pre- and post- of the 2016 election as two distinct epochs in a bifurcated national history. The "not" of #NotNormal or #NotMyPresident speaks to a thousand political norms that changed with dizzying speed in the first months of the Trump presidency—boorishness and ignorance as expected presidential idioms; Nuremberg-like rallies as "the people's" forums even after the campaign was over; governance by the fiat of executive order; life-and-death policies announced (or merely teased and threatened) via Twitter; a blind eye to long-standing norms of ethics and conflicts of interest; blatant disregard for the separation of powers; the staffing of government agencies by men and women who openly despised them; repeated White House assaults on the free press as "enemies of the people"; and mendacity taken to heights that Nixon and his wrecking crew of a White House never even dreamed of, beginning with the bald, day-one assertion of "the largest audience to witness an inauguration—period."

But even so, Trumpism is best understood as a particular outcropping that juts—conspicuously, perhaps, and even uniquely, but continuously nonetheless—from a much greater and deeper and longer-lived formation of American political thought and feeling. While many journalists and scholars understandably struggle to assure that Donald Trump's affinity with white nationalists like Steve Bannon, Richard Spencer, or the torch-bearing marchers of Charlottesville does not become "normalized," an equally pressing task might be to keep a cool eye on the relationship between the "norms" and the "extremes" in U.S. political culture in the first place—between the entwined histories of democracy and racism—and to assure that we do not *denaturalize* by collective, Trump-inspired delusion the core principles of racism that have deeply structured our political history, from the three-fifths compromise on down. Such continuity is part of what my camera found in the Obama years, before Trumpism even had a name.

In retrospect, I understand the historical work of the camera in two ways, and I understand this project itself as a sequence of two corresponding modes of meditation. My fieldwork, as I wrote at the outset, was something like a second apprenticeship as an historian, almost a second PhD—this time an education in *seeing and framing* rather than researching and writing. I always meant for it to matter deeply in the Historian's Eye project that the "eye" was an historian's—that the photographer was "I." My fieldwork was devoted to documenting "the past in the present and history in the making"; and while I cannot in every instance articulate the differ-

ence between my practices and those of a photojournalist, say, I do know that on my best days I was working the same part of my brain that I worked while writing *Whiteness of a Different Color* or *Barbarian Virtues*. On the one hand, I was learning to read the visual artifact of the past as it reveals itself in the present—to read implicit narratives in the architectural cue of a silent factory, for instance, or to recognize the vicissitudes of fortune suggested in the scene of an opulent vintage car now abandoned behind the chain-link fence of a failed car lot (signs announcing "guaranteed financing" notwithstanding). And on the other hand, I was learning new habits of mind by which the historical imagination is never at rest, by which every landscape is made to render comment on "this historical moment." An American flag behind a cracked store window; a ghostly San Antonio street; a hateful banner decrying Islam; an intimate Obama portrait painted on the wall of a BBQ kitchen; a limousine speeding past a block of shuttered stores. Each shot speaks to its moment, to be sure, but each also speaks to the flow and layers of historical time. My oral history interviews were a crucial part of this process. My own roving eye and the thousands of images I shot were scripted and directed, as it were, in the scores of conversations I had—with poets, artists, unemployed office managers, investment bankers, grocers, activists, journalists, judges, teachers,

carpenters, bartenders—about the paths they had cut through the decades to arrive in the present, and their own understandings of "this historical moment." But the first meditation in this meditative practice was the one that took place with camera in hand: the historian's assessment of past and present as they appeared through the viewfinder.

I embarked on a second meditation upon viewing each image, upon the moment of scrutiny and interpretation. Those tasked or empowered to assemble an archive are rarely the same people who will sift and interpret that archive's materials after the fact. I had not necessarily designed the project or my role in it with this intention; but the fact that I was both the fieldworker who amassed the Historian's Eye archive between 2009 and 2014 *and* the historian who returned to interpret it later on has turned out to be an important and thrilling exercise. The difference between that split-second decision with the camera in hand and that full-on viewing with hours to edit and reflect is something like the difference between a hunch and a treatise. Certain aspects of the hunch, no treatise will ever improve upon. But the fullness of time, the luxury of reflection and further inquiry, the invitation to research, the accidental association—each of these has added depth and variety to my reading of the images, each is quite distinct from the "intent" of the images (even

though that intent was my own), each has led me to either build upon or depart from the initial hunch that authored the photograph in the first place, but in either case these readings after the fact take place in a wholly different register and they tend to lead to insights and conclusions that are far removed from the click of the shutter. If there is an articulable pedagogy embodied in *The Historian's Eye*, it is in this—the modeling of these two distinct brands of historical meditation in practice, the split-second hunch and the sustained contemplative reverie. Each pairing of image and accompanying text in *The Historian's Eye* is meant to suspend the reader between the temporalities of these two modes of reflection and insight.

Which leads me, finally, now that I think of it, to one further mode of meditation. We speak of photographs as "freezing" a moment in time, "capturing for eternity" the flash of a fleeting instant. But my experience has been that there is really no such "freezing," that an image will retain an uncanny property of fluidity and motion just as long as its viewers are living, breathing, thinking people whose own "moment" is in motion and for whom history will never stand still. "It isn't that the past casts its light on what is present or that what is present casts its light on what is past," writes Walter Benjamin; "rather, an image is that in which the Then and the Now come together, in a flash of light-

ning, into a constellation. In other words, an image is dialectics at a standstill."[1] It has been striking to me these past months, as I have presented this work in university settings from Connecticut to Virginia to New York to Pennsylvania throughout 2017, that the response has been quite different from one month to the next. The presentations have been identical; the audiences have all been similar gatherings of students and faculty members in American Studies or history departments. The salient variable has been the proximity or distance from the 2016 election, and the stage of reckoning that the audience has achieved in their absorption of that calamity. Very different aspects of the archive have "popped" for audiences from one season to the next; different avenues of concern and comment have been traveled in our discussions, depending on where people see themselves in relation to the "text" of "the American present." Images that evoked great sadness right after the election—such as some of the Obama iconography—met with a palpable sense of collective enjoyment, almost relief, later on. Others, like the more disturbing images of the Islamophobic rally in New York, have met with increasing expressions of recognition and comprehension as the months of Trump's presidency have passed. To think, when I first started lecturing on the Historian's Eye back in 2010, it could be a real challenge to convince people that such things represented

a significant feature of our political landscape. Which is just to acknowledge that, like people and like history itself, a photograph's meaning is never settled or fixed. If this volume represents an invitation to reflect on history through the practices of photography, as outlined above, it is also an invitation to take one's own historical temperature, so to speak, through the practices of viewership. The question is not only *What does this historical moment look like where you live?* but also, *What does this particular archive evoke in you at this historical moment? Or at this one? Or again at this one?*

As for the ever-changing same of the American present, in the year Trump+1 I find that I can do no better for this afterword than to end with the same words I wrote over a year ago, as I closed out the body of *The Historian's Eye* on the image of an intrepid woman wearing a sandwich sign proclaiming, "Hate is NOT an American value":

> I have to answer, if I'm honest, that the verdict is still out on that one, that it strikes me as more aspirational than factual. But it is a worthy aspiration, and there is much in our intellectual and moral inheritance, from Lydia Maria Child to John Lewis, to light us the way. The best each of us can offer—the very least we *must* do, the very most we *can* do—is to fight our hardest to make this slogan so.

Acknowledgments

All scholarship and creative work is collaborative, but I have been more keenly aware of this than ever in working on *The Historian's Eye*. The project benefited beyond measure from the advice, support, expertise, and kindness of countless friends, acquaintances, colleagues, and generous strangers.

This work began as a web-based documentary. My web design and technical support team at Yale was a dream to work with: Pamela Patterson, Ken Panko, Alison Kanosky. Our early brainstorming sessions, where we viewed materials together in order to discover their meaning and dream up a suitable format for them, were absolutely thrilling collaborations—I'm not sure I have ever learned so much so quickly. Alison Kanosky in particular, as she grew from data management intern on the website to Associate Editor of the project overall, was an indispensable colleague in this work all along the way, including incisive commentary on the book manuscript. Pam Patterson has continued to be a great ally and friend in the years since we launched the website. Her technical skills, her instincts for data management, her good humor, and her friendship were critical in seeing this work into print.

My students and colleagues in American Studies and Public Humanities at Yale have provided crucial support, encouragement, and advice. As ever. I came to Yale twenty-some years ago, not necessarily expecting to be invited to stay, but figuring that I'd learn an awful lot from hanging around with this crowd as long as they'd allow it. That has remained true every single day. My longtime colleagues Jean-Christophe Agnew, Hazel Carby, Michael Denning, Kate Dudley, Glenda Gilmore, Zareena Grewal, Dolores Hayden, Jonathan Holloway, Katie Lofton, Mary Lui, Joanne

Meyerowitz, Charlie Musser, Steve Pitti, Elihu Rubin, and Alicia Schmidt Camacho will recognize pieces of themselves in this work, if I have done it right. A very special thank you to Laura Wexler, who helped me to think about photography as both form and practice, and whose enthusiasm for troubling our standard academic processes has stamped me indelibly. George Chauncey gave me a priceless little push at the very beginning—encouragement (or was it permission?) one snowy night on the Upper West Side in 2009, to think seriously about the camera and the digital recorder as instruments for historical inquiry. Emily Bakemeier, in the provost's office, has always been most encouraging and generous in making a space for Public Humanities at Yale. The famous "Group of 33"—they know who they are—have been inspiring models for inhabiting an institution like Yale while holding true to one's own ideals. With any luck, their commitments, too, are reflected in this work.

Thanks as well to Monica Martinez and Ryan Brasseaux, whose agitation around Public Humanities changed both my institutional life and my intellectual life forever. Seth Fein, Karin Roffman, Rebecca Jacobs, Seth Moglen, Josh Kun, Anne McClintock, Jack Tchen, Joe McNally, Gaspar Gonzalez, and Christopher Comerford have been important interlocutors in ways that they may not have even been aware of, as have my students in the Public Humanities and Introduction to Documentary Studies, and my colleagues in the Northeastern Public Humanities Consortium. Renee Athay was an important inspiration, mentor, and co-conspirator in the early stages of this work—she deserves a Pulitzer for her portraits of faces in the crowd at the first Obama inauguration, if you ask me. I have also benefitted greatly from my conver-

sations with audience members who turned up for Historian's Eye presentations at George Mason, Lehigh, Yale, Stony Brook, the University of Miami, Princeton, UC Berkeley, Harvard, Pitzer College, the University of Alabama, Tulane, NYU, Dickenson, Vanderbilt, San Diego State, CUNY Grad Center, Karlstad University (Sweden), and Sophia University (Japan).

The group at UNC Press represents the very best of my professional good luck. Mark Simpson-Vos took an early and genuine interest in this documentary work as a potential book; he worked with me through the stages from web and gallery to printed volume with great insight and a wonderful respect for what the project was trying to accomplish. Tom Rankin made an important set of design interventions at a time when I needed them most, articulating ideas that showcased the work in ways I had never conceived of. Jessica Newman was tireless in her help with the many technical details involved in transferring the images from cyberspace to print, from New Haven to Chapel Hill. I am beyond grateful to have ended up in this particular shop for my first documentary volume.

Friends and fellow travelers across the country lent an enormous hand with the logistics of the travel and fieldwork associated with the project: Eleanor Byrne in Boston; Louise Newman in Gainesville, Florida; Dean Toji in Los Angeles; Peter Rachleff in Minneapolis–St. Paul; Daphne Brooks and Mark Krasovic in New Jersey; Don Hubbard, Jana Lipman, and Joel Dinerstein in New Orleans; the congregation of Da'at Elohim/ TUJ in New York; Leah Perry in Washington, D.C.; William Weir in Seattle; Robin Burt, Fletcher Ward, and Pamela James Corwin in Olympia, Washington; Lynne Adrian and Eric Weisbard in Tuscaloosa, Ala-

bama; Michael Cohen, Leigh Raiford, and Alaska Quilici in Berkeley, California.

I am especially grateful to everyone who consented to sit down with me for an interview. My understanding of the historical moment and many of my ideas about what to shoot derived from the wisdom and the rigor of my many interviewees along the way: Margaret Bodell, Gary Bretton-Granatoor, Nora Burn, Leonette Butler, Michael Cohen, Sarah Cox, Lizzie D'Sousa, Thomas Dyja, Rosilyn Edgerton, Zac Fabian, Bonnie Fox, Jean Geller, Shepard Geller, Bernie Hesse, Carol Hogue, Alvin Jackson, Jerry Jacobson, Seitu Jones, Steve Jones, Daisy Kahn, Lesley Karsten-DiNicola, Mayalan Keita-Brown, Sarah Klein, Wendy Knox, Paul Landry, Alejandro Lara-Briseno, Min Jin Lee, Ricardo Levins Morales, Eleanor Lewis, Jimee Lowe, Timothy McCarthy, Cyrus McGoldrick, David Montana, Bob Moses, Fred Moten, Chase Neisner, Sheila Payne, Maria Pineda, Ann Powers, Vinay Prasad, Sarah Queener-Plourde, Ivo Rabell, Leigh Raiford, Paul Rauschenbush, Vic Rosenthal, Dan Russo, Alicia Schmidt Camacho, Betty Shamieh, Cliff Simms, Nikhil Singh, Jim Sleeper, Nettie Smith, Margaret Southern, Nick Spitzer, Lonnie Tanner, Kathleen Toomey, Robert Viscusi, Dorothea Von Moltke, Mark Walsh, and Greg Welk. Their interviews can be accessed in raw audio, edited, or transcript form at www.historianseye.org.

My parents, Jerry and the late Sarah Jacobson, encouraged me to challenge convention and to disrespect boundaries wherever I found them. I don't know exactly all the ways they conveyed this message, but I do know that the most important things I have accomplished in my life are things that a) cut against someone's grain, but b) made total sense if you grew up in the household I did. There is not a greater tribute I can pay them than to simply name this. My children, Nick and Tess, have kept me ever hopeful and focused on a better future, even when a debased present has made that seem more and more uncertain. In as much as I can, I apologize to them on behalf of all their elders—as Tess in particular demands—for the world they inherit. If they do manage to wrangle from our future a present that well represents their own virtues, then we will all be all OK. Love and hope. In the meantime, all my fighting is on their behalf.

My partner, Daphne Brooks, took a wry but always genuine and intellectually challenging interest in this work. "I hope you find a lot of good misery out there," she would say, as I left the house with my photography gear. She meant this as irony, support, and moral compass all at once, which is what I adore about her. *Historian's Eye* is a work about many things, but for me it's always been largely a work about beauty. Daphne Brooks has been my own personal godsend in keeping me attuned to that.

Notes

INTRODUCTION

1. Paula Rabinowitz, *They Must Be Represented: The Politics of Documentary* (New York: Verso, 1994), 7. In addition to Rabinowitz, my own conclusions about documentary practices and their stakes derive from Louise Spence and Vinicius Navarro, *Crafting Truth: Documentary Form and Meaning* (New Brunswick, N.J.: Rutgers University Press, 2012); Susan Sontag, *Regarding the Pain of Others* (New York: Picador, 2003); and Errol Morris, *Believing Is Seeing: Observations on the Mysteries of the Photograph* (New York: Penguin, 2011).

2. Robert Coles, *Doing Documentary Work* (New York: Oxford University Press, 1997), 250–51.

3. Linda Gordon, *Dorothea Lange: A Life Beyond Limits* (New York: W. W. Norton, 2010), xviii. Quoted somewhat differently but to the same effect in Milton Meltzer, *Dorothea Lange: A Photographer's Life* (New York: Farrar, Straus & Giroux, 1985), vii.

4. See Chloe Taft, *From Steel to Slots: Casino Capitalism in the Postindustrial City* (Cambridge: Harvard University Press, 2016).

5. Ronald Takaki, *Iron Cages: Race and Culture in Nineteenth Century America* (New York: Knopf, 1979), 3–66, on race and republicanism; Ronald Takaki, "Reflections on the Racial Pattern in America," in *From Different Shores: Perspectives on Race and Ethnicity in America*, ed. Ronald Takaki (New York: Oxford University Press, 1987), 26–37, on 1790. On the 1924 act, see Mae Ngai, *Impossible Subjects: Illegal Aliens and the Making of Modern America* (Princeton, N.J.: Princeton University Press, 2004). My own extended analysis of race and citizenship can be found in *Whiteness of a Different Color: European Immigrants and the Alchemy of Race* (Cambridge: Harvard University Press, 1998), 15–38.

6. Rose Eveleth, "How Many Photographs of You Are Out There in the World?" *The Atlantic*, November 2, 2015. http://www.theatlantic.com /technology/archive/2015/11/how-many-photographs -of-you-are-out-there-in-the-world/413389/ (accessed June 23, 2016).

CHAPTER 1

1. Barack Obama, *Dreams from My Father: A Story of Race and Inheritance* (1995; repr., New York: Broadway Paperbacks, 2004), xiii.

2. http://hopedespair.yctl.org/ricardo-levins -morales-interview-transcript/.

3. Michael Eric Dyson, *The Black Presidency: Barack Obama and the Politics of Race in America* (Boston: Houghton Mifflin Harcourt, 2016), ix.

4. Matthew Frye Jacobson, *Whiteness of a Different Color: European Immigrants and the Alchemy of Race* (Cambridge: Harvard University Press, 1998), 27.

5. Thomas Dyer, *Theodore Roosevelt and the Idea of Race* (Baton Rouge: Louisiana State University Press, 1980), 140. This is not to suggest that the egalitarian impulse in U.S. political culture was entirely lacking. See for example Robin D. G. Kelley, *Freedom Dreams: The Black Radical Imagination* (Boston: Beacon, 2003); and Lon Kurashige, *Two Faces of Exclusion: The Untold History of Anti-Asian Racism in the United States* (Chapel Hill: University of North Carolina Press, 2016).

6. https://en.wikipedia.org/wiki/List_of_things _named_after_Barack_Obama#Biota (accessed August 9, 2016).

7. *STL Rising* at http://stlrising.blogspot.com /2011/08/barack-obama-boulevard.html (accessed August 9, 2016).

8. http://rmc.library.cornell.edu/obama/ (ac-

cessed August 10, 2016); https://materialculture
.com/obama-lehigh-show/ (accessed August 10,
2016).

9. http://www.billboard.com/articles/columns
/the-juice/474274/barack-obama-10-best-songs
-about-the-president (accessed August 10, 2016).

10. "Obama Visits Baseball Hall of Fame to
Boost Tourism," Syracuse.com, May 22, 2014, at
http://www.syracuse.com/news/index.ssf/2014/05
/obama_visits_cooperstown_to_boost_tourism
.html (accessed August 15, 2016).

11. Robert Weisbrot, *Freedom Bound: A History of
America's Civil Rights Movement* (New York: Plume,
1991), 223.

12. https://mlb.nbcsports.com/2011/07/27/quote
-of-the-day-sergio-romo-likes-obama/.

13. California Secretary of State, "Supplement
to the Statement of Vote: Statewide Summary
by County for United States President" https://
elections.cdn.sos.ca.gov/sov/2008-general/ssov/4
-pres-statewide-summary-by-county.pdf (accessed
August 14, 2016); Amelia Rosch, "4 Reasons Pro-
gressives Can Be Glad the San Francisco Giants
Won the World Series," *Think Progress*, October
30, 2014, at https://thinkprogress.org/4-reasons
-progressives-can-be-glad-the-san-francisco-giants
-won-the-world-series-d7f8166fef84#.q6tfvz5n3
(accessed August 12, 2016).

14. "Stephen Colbert, Jon Stewart 'Rally to Re-
store Sanity and/or Fear' Draws Thousands of New
Yorkers," *Daily News*, October 31, 2010, at http://
www.nydailynews.com/news/politics/stephen
-colbert-jon-stewart-rally-restore-sanity-fear-draws
-thousands-new-yorkers-article-1.192796 (accessed
August 20 2016).

15. "Written Submission of the American Civil
Liberties Union on Racial Disparities in Sen-
tencing; Hearing on Reports of Racism in the Jus-
tice System of the United States, submitted to the
Inter-American Commission on Human Rights,"
153rd session, October 27, 2014, at https://www
.aclu.org/sites/default/files/assets/141027_iachr

_racial_disparities_aclu_submission_0.pdf. See
also Kristin Zimmerman, "The Unfair Sentencing
Act: Racial Disparities and Fiscal Consequences of
America's Drug Laws," *Themis: Research Journal of
Justice Studies and Forensic Science* 2, no. 1 (2014):
160–75, at http://scholarworks.sjsu.edu/cgi/view
content.cgi?article=1013&context=themis (ac-
cessed August 20, 2016).

16. Credit is due Allegra Gibbons-Shapiro and
Daphne Brooks, for whom "You know why" is the
sharp, ready answer to any question where the
racial factor ought to be obvious. Why do they hate
Obama so much? You know why. Why did they pull
her over in the first place? You know why. Why
are there three movies about Bridget Jones and no
movies about Harriet Tubman? You know why . . .
Repeat as needed.

17. Michele McPhee, "Obama: Police Acted
'Stupidly' in Gates Case," ABC News, July 22, 2009,
at http://abcnews.go.com/US/story?id=8148986
(accessed August 11, 2016); Byron Tau, "Obama:
'If I Had a Son, He'd Look Like Trayvon,'" *Politico*,
March 23, 2012, at http://www.politico.com/blogs
/politico44/2012/03/obama-if-i-had-a-son-hed
-look-like-trayvon-118439 (accessed August 10,
2016); https://www.whitehouse.gov/the-press
-office/2013/07/19/remarks-president-trayvon
-martin (accessed August 11, 2016).

18. http://blogs.wsj.com/washwire/2008/03/18
/text-of-obamas-speech-a-more-perfect-union/.

19. David Sims, "The President's Candid Garage
Interview," *The Atlantic*, June 22, 2015, at http://
www.theatlantic.com/entertainment/archive/2015
/06/obama-wtf-marc-maron/396488/ (accessed
July 1, 2016).

20. Ashley Parker and Steve Eder, "Inside the
Six Weeks That Donald Trump Was a Non-Stop
Birther," *New York Times*, July 2, 2016, at http://
www.nytimes.com/2016/07/03/us/politics/donald
-trump-birther-obama.html?_r=0 (accessed August
11, 2016).

21. Fred Moten at http://hopedespair.yctl.org

/category/edited-audio-interviews/ (accessed August 13, 2016).

22. Nikhil Singh comments here and below at http://hopedespair.yctl.org/nikhil-singh-interview -transcript-2010/ (accessed August 12, 2016).

23. Terry Gross, *Fresh Air*, National Public Radio, September 14, 2016.

24. "Donald Trump Has Been Self-Funding His Bigotry on Parade since at Least 1989," *The Huffington Post*, February 19, 2016, at http://www .huffingtonpost.com/entry/donald-trump-central -park-five_us_56c78713e4b041136f16fd4e (accessed August 13, 2016); "Donald Trump and the Central Park Five: The Racially Charged Rise of a Demagogue," *The Guardian*, February 17, 2016, at https:// www.theguardian.com/us-news/2016/feb/17 /central-park-five-donald-trump-jogger-rape-case -new-york (accessed August 13, 2016).

25. "Trump Sends Investigators to Hawaii to Look into Obama," CNN.com, April 7, 2011, at http://politicalticker.blogs.cnn.com/2011/04/07 /trump-sends-investigators-to-hawaii-to-look-into -obama/ (accessed August 14, 2016).

26. "Obama Campaign Selling Birth Certificate Buttons," *Newsmax*, August 27, 2012, at http://www .newsmax.com/US/obama-birth-certificate-buttons /2012/08/27/id/449949/ (accessed July 17, 2016).

27. "Obama Mocks Trump over 'Growing Up Together in Kenya,'" *USA Today*, October 25, 2012, at http://www.usatoday.com/story/theoval/2012/10 /25/obama-trump-leon-kenya/1656397/ (accessed August 13, 2016).

28. "Obama Lampoons Trump, Releases 'Birth Video' at Annual Dinner," CNN.com, May 2, 2011, at http://www.cnn.com/2011/POLITICS/05/01 /white.house.correspondents.dinner/ (accessed August 13, 2016).

29. Here and below: http://hopedespair.yctl.org /paul-landry-interview-transcript/.

30. http://hopedespair.yctl.org/sheila-payne -full-interview/ (accessed August 16, 2016).

31. "Obama Election a Boon for Gun Dealers,"

Gainesville Sun, November 25, 2012, at http://www .gainesville.com/news/20121125/obama-re-election -a-boon-for-gun-dealers/1 (accessed August 16, 2016).

CHAPTER 2

1. Viet Thanh Nguyen, *The Sympathizer: A Novel* (New York: Grove Press, 2015), 35.

2. Joseph Stiglitz, *Freefall: America, Free Markets, and the Sinking of the World Economy* (New York: W.W. Norton, 2010), 219.

3. http://ci.chehalis.wa.us/visitors/29-chehalis -garage-chehalis-theater-1923–558-north-market -boulevard (accessed June 24, 2016).

4. Richard Broadman, dir., *Mission Hill and the Miracle of Boston*, DER Films, 1978.

5. Rachel Hock, "The Land That Boston Forgot," *DigBoston*, October 14, 2015, at https://digboston .com/special-feature-the-land-boston-forgot/ (accessed September 22, 2016). See also Shin Eunjung, *Verita$: Harvard's Hidden History* (Oakland: PM Press, 2015).

6. Thomas Frank, *Listen, Liberal: What Ever Happened to the Party of the People?* (New York: Metropolitan Books, 2017), 139.

7. IGM Forum, at http://www.igmchicago.org /igm-economic-experts-panel/poll-results?SurveyID =SV_cw5O9LNJL10z4Xi (accessed July 14, 2016).

8. Frank, *Listen, Liberal*, 146–47. "Recovery Logo Is Obama's Audacity," at https://ahrcanum.com /tag/american-recovery-and-reinvestment-act/ (accessed July 14, 2016).

9. Nick Wing, "Newt Gingrich: Health Care Reform Is 'Centralized Health Dictatorship,'" *Huffington Post*, January 19, 2011, http://www.huffington post.com/2011/01/19/newt-gingrich-health-care -dictatorship_n_810924.html; Megan Carpentier, "Michele Bachmann: 'Obamacare Is a Crime Against Democracy,'" *Rawstory*, March 6, 2011, http://www.rawstory.com/2011/03/michele -bachman-obamacare-is-a-crime-against-democ racy/; M. J. Lee, "10 Best Pro and Con Healthcare

Quotes," *Politico*, March 29, 2012, http://www
.politico.com/story/2012/03/10-best-pro-con
-health-care-quotes-074638 (all accessed June 28,
2016).

10. https://www.facebook.com/DefeatTheDebt/
(accessed June 5, 2016).

11. "Newt and the 'Food Stamp President," *The
Economist*, June 18, 2012. http://www.economist
.com/blogs/democracyinamerica/2012/01/newt
-gingrich (accessed June 5, 2016).

12. Congressional Budget Office, "The Budget
and Economic Outlook: Fiscal Years 2010 to
2020," January 26, 2010, at https://www.cbo.gov
/publication/41880 (accessed June 5, 2016).

13. Juan Gabriel Valdes, *Pinochet's Economists:
The Chicago School in Chile* (New York: Cambridge
University Press, 1995), 22, 7.

14. *Time*, January 31, 1965. http://www.time
.com/time/magazine/article/0,9171,842353,00.html.
The quote is often mistakenly attributed to Richard
Nixon.

15. Quoted in David Harvey, *A Brief History of
Neoliberalism* (New York: Oxford University Press,
2005), 20.

16. Harvey, *Brief History*, 36.

17. Harvey, *Brief History*, 28, 33; Robert Reich,
Saving Capitalism for the Many, Not the Few (New
York: Vintage, 2016), 115–32.

18. Richard Peet, *Unholy Trinity: The World Bank,
IMF and WTO*, 2nd ed. (New York: Zed Books,
2010), 14–16, 89.

19. Peet, *Unholy Trinity*, 87.

20. Lewis Mumford, *The City in History: Its Ori-
gins, Its Transformations, and Its Prospects* (New
York: Harvest, 1961), 99.

21. David Harvey, *The New Imperialism* (New
York: Oxford University Press, 2003), 64.

22. Isabell Lorey, *State of Insecurity: Government
of the Precarious* (London: Verso, 2015), 89; Robert
Reich, *Beyond Outrage: What Has Gone Wrong with
Our Economy and Our Democracy, and How to Fix It*
(New York: Vintage, 2012), 41–53.

23. Wendy Brown, "Neoliberalism and the End

of Liberal Democracy," in *Edgework: Critical Essays
on Knowledge and Politics* (Princeton: Princeton
University Press, 2005), 43.

24. Brown, "Neoliberalism and the End of Lib-
eral Democracy," 46–47.

25. Christopher Hayes, *The Twilight of the Elites:
America After Meritocracy* (New York: Broadway
Paperbacks, 2012), 19.

26. Todd Gitlin, *The Twilight of Common Dreams:
Why America Is Wracked by Culture Wars* (New York:
Holt, 1996), 103 126; Robin D. G. Kelley, *Freedom
Dreams: The Black Radical Imagination* (Boston:
Beacon, 2003). On the renewed public language of
political economy and class, see Reich, *Saving Capi-
talism*; Janet Byrne, ed., *The Occupy Handbook* (Bos-
ton: Back Bay, 2012); Todd Gitlin, *Occupy Nation:
The Roots, the Spirit, and the Promise of Occupy Wall
Street* (New York: It Books, 2012).

27. John Adams, *Without Precedent: The Story of
the Death of McCarthyism* (New York: W.W. Norton,
1983), 227–29.

28. Hayes, *Twilight of the Elites*, 102.

29. Vijay Prashad, "Between 'Black Lives Matter'
and 'Make America Great Again': Two Outcomes of
America's Political Economy," paper delivered for
the Ethnicity, Race & Migration Program at Yale
University, February 24, 2016.

30. Judith Butler, *Notes Toward a Performative
Theory of Assembly* (Cambridge: Harvard University
Press, 2015), 52, 67.

31. *New York Times*, February 5, 2008, 5.

32. The Historian's Eye website, at http://hope
despair.yctl.org/category/edited-audio-interviews/
(accessed July 8, 2016).

33. The Historian's Eye website, at http://hope
despair.yctl.org/protests/nggallery/page/7#gallery
/14479/651 (accessed July 8, 2016).

34. Wendy Brown, *Undoing the Demos: Neolib-
eralism's Stealth Revolution* (Brooklyn: Zone Books,
2015), 26, 70; Lorey, *State of Insecurity: Government
of the Precarious*, 63–71. On the intellectual under-
pinnings Occupy, see Byrne, *Occupy Handbook*.

35. The Historian's Eye website at http://hope

despair.yctl.org/protests/nggallery/page/7 (accessed July 10, 2016).

36. Butler, *Notes Toward a Performative Theory of Assembly*, 158. On freedom of assembly, see also Gitlin, *Occupy Nation*, 242–49.

37. The full interview is at http://hopedespair .yctl.org/category/raw-audio-archive/page/2/ (accessed August 23, 2016).

38. Robin D. G. Kelley, "The U.S. v. Trayvon Martin: How the System Worked," *Huffington Post*, July 15, 2013, http://www.huffingtonpost.com /robin-d-g-kelley/nra-stand-your-ground-trayvon -martin_b_3599843.html (accessed June 26, 2016).

39. Bureau of Labor Statistics, http://data.bls .gov/timeseries/LAUMT361378000000004?data _tool=XGtable (accessed July 5, 2016).

40. Jill Lepore, *The Whites of Their Eyes: The Tea Party's Revolution and the Battle over American History* (Princeton: Princeton University Press, 2011), 71–72.

41. Gitlin, *Occupy Nation*, 12.

42. Gitlin, *Occupy Nation*, 226.

43. "Norman Lear on Fighting the Good Fight," *Los Angeles Times*, December 30, 2011, at http:// articles.latimes.com/2011/dec/30/opinion/la-oe -lear-occupy-the-new-year-20111230 (accessed August 22, 2016).

44. Ben Yakas, "Rudy Giuliani Would Have Kicked Out Occupy Wall Street Bums on Day One," Gothamist.com, at http://gothamist.com/2011/11 /18/rudy_giuliani_would_have_kicked_out.php (accessed August 25, 2016).

45. Errol Morris, *Believing Is Seeing: Observations on the Mysteries of Photography* (New York: Penguin, 2011), 20.

46. Gitlin, *Occupy Nation*, 113–14.

CHAPTER 3

1. "Further Slide Seen in Commercial Real Estate," *New York Times*, January 8, 2010, A1.

2. http://hopedespair.yctl.org/bonnie-fox-inter view-transcript/.

CHAPTER 4

1. Lange quoted in Milton Meltzer, *Dorothea Lange: A Photographer's Life* (New York: Farrar, Straus & Giroux, 1985), vii. I am also indebted to my colleague Laura Wexler for the "nothing to see here" analogy.

2. Margaret Mead quote, permission of the Institute for Intercultural Studies. Their website remarks, "Although the Institute has received many inquiries about this famous admonition by Margaret Mead, we have been unable to locate when and where it was first cited, becoming a motto for many organizations and movements. We believe it probably came into circulation through a newspaper report of something said spontaneously and informally. We know, however, that it was firmly rooted in [Mead's] professional work and that it reflected a conviction that she expressed often, in different contexts and phrasings." http://www.inter culturalstudies.org/faq.html#quote_use (accessed September 9, 2016).

3. Anne McClintock, "Slow Violence and the BP Oil Crisis in the Gulf of Mexico: Militarizing Environmental Catastrophe," at http://hemispheric institute.org/hemi/en/e-misferica-91/mcclintock.

4. Robert Reich, *The Work of Nations* (New York: Vintage, 1991), 8, 282 ff.; Robert Reich, *Saving Capitalism for the Many, Not the Few* (New York: Vintage, 2016), 97–107; Joseph Stiglitz, *Freefall: America, Free Markets, and the Sinking of the World Economy* (New York: W.W. Norton, 2010), 151–53.

5. Christopher Hayes, *The Twilight of the Elites: America after Meritocracy* (New York: Broadway Paperbacks, 2012), 177–215, 212; Robert Reich, *Beyond Outrage: What Has Gone Wrong with Our Economy and Our Democracy, and How to Fix It* (New York: Vintage, 2012), 28–37; on the highway system, driving, and democracy, see Cotten Seiler, *Republic of Drivers: A Cultural History of Automobility in America* (Chicago: University of Chicago Press, 2008).

6. Michael Tesler and David O. Sears, *Obama's Race: The 2008 Election and the Dream of a Post-*

Racial America (Chicago: University of Chicago Press, 2010), 142, 144, 154; 75–93. Tesler and Sears predict that "political decision making could become increasingly organized by racial attitudes in the years ahead" (142), a judgment that Trumpism seems to bear out.

7. Quoted in "Walter Rosenblum: Lewis Hine, Paul Strand, and the Photo League," in Ken Light, *Witness in Our Time: Working Lives of Documentary Photographers* (Washington, D.C.: Smithsonian Books, 2000), 32.

8. Robert Coles, *Doing Documentary Work* (New York: Oxford University Press, 1997), 177.

9. Coles, *Doing Documentary Work*, 15, 74.

10. "Barry Goldwater Speaks Out for a Stronger America," http://www.4president.org/brochures/goldwater1964brochure.htm (accessed June 3, 2016).

11. Reich, *Beyond Outrage*, 23–25.

12. Julian Barnes, "A Nation Challenged: Proud Spirits; As Demand Soars, Flag Makers Help Bolster Nation's Morale," *New York Times*, September 23, 2001, at http://www.nytimes.com/2001/09/23/business/nation-challenged-proud-spirits-demand-soars-flag-makers-help-bolster-nation-s.html (accessed Sept. 1, 2016).

13. Dana Heller, *The Selling of 9/11: How a National Tragedy Became a Commodity* (New York: Palgrave, 2005), 6. See also Lucy Bond, *Frames of Memory after 9/11: Culture, Criticism, Politics, and Law* (New York: Palgrave, 2015).

14. "McCain: Bush Sent Wrong Message after 9/11," CBS News, October 3, 2007, at http://www.cbsnews.com/news/mccain-bush-sent-wrong-message-after-9-11/ (accessed September 1, 2016).

15. Kelly Lytle-Hernandez, *Migra! A History of the U.S. Border Patrol* (Berkeley: University of California Press, 2010), 46–48.

16. Monica Alonzo, "Cloaked Brutality: The Feds Bury Border Patrol Abuses of Immigrants, But What's Been Unearthed Reveals a Culture of Cruelty," *Phoenix New Times*, December 16, 2010, at http://www.phoenixnewtimes.com/news/cloaked-brutality-the-feds-bury-border-patrol-abuses-of-immigrants-but-whats-been-unearthed-reveals-a-culture-of-cruelty-6446900 (accessed September 12, 2012).

CHAPTER 5

1. "Black Church Arson Seemingly Sparked by Obama Election Brings Civil Rights Guilty Plea," CBS News, June 17, 2010, at http://www.cbsnews.com/news/black-church-arson-seemingly-sparked-by-obama-election-brings-civil-rights-guilty-plea/ (accessed June 14, 2016).

2. Robert Draper, *Do Not Ask What Good We Do: Inside the U.S. House of Representatives* (New York: Free Press, 2012), x; Jason Horowitz, "Republican Strategists Return to the Table, Hungering for a Way Forward," *Washington Post*, January 20, 2013.

3. "Ted Cruz Calls Obama Communist, Gloats about Boehner Quitting, Threatens to Assassinate Iran's Supreme Leader," *Trail Blazer's Blog*, September 25, 2015, at http://trailblazersblog.dallasnews.com/2015/09/ted-cruz-calls-obama-communist-gloats-about-boehner-quitting-threatens-to-assassinate-irans-supreme-leader.html/ (accessed July 17, 2016).

4. Carol Anderson, *White Rage: The Unspoken Truth of Our Racial Divide* (New York: Bloomsbury, 2016), 138–60.

5. Alabama, Arizona, Indiana, Kansas, Mississippi, Nebraska, New Hampshire, Ohio, Rhode Island, South Carolina, Tennessee, Texas, Virginia, and Wisconsin.

6. Anderson, *White Rage*, 156.

7. I am getting my numbers from the Pew Research Center. On immigration rates, see http://www.pewresearch.org/fact-tank/2015/11/19/5-facts-about-illegal-immigration-in-the-u-s/. On the rising deportation figures during the Obama years, see http://www.pewresearch.org/fact-tank/2014/10/02/u-s-deportations-of-immigrants-reach-record-high-in-2013/ (accessed June 21, 2016).

8. Jill Lepore, *The Whites of Their Eyes: The Tea Party's Revolution and the Battle over American*

History (Princeton: Princeton University Press, 2011), 37.

9. http://www.teaparty.org/impeach-obama -petition/; https://larouchepac.com/obamawatch (both accessed August 28, 2016).

10. Jamelle Bouie, "You Know Who Else Said That? My Favorite Examples of Republicans Comparing Obama to Hitler," *Slate*, Jan. 13, 2015, at http://www.slate.com/articles/news_and_politics /politics/2015/01/republicans_comparing_barack _obama_to_hitler_my_favorite_examples_of_the .html; and "Like Hitler, Really?," *Boston Globe*, August 10, 2015, at https://www.bostonglobe.com /opinion/2015/08/09/like-hitler-really/Vl9J2mbKjg Kk53ECK15siN/story.html (both accessed August 28, 2016).

11. Michael Eric Dyson, *The Black Presidency: Barack Obama and the Politics of Race in America* (Boston: Houghton Mifflin Harcourt, 2016), 78–79, 191.

12. Brady McCombs, "Border Boletin: Sheriff Babeu Says He Doesn't Endorse Oracle Billboard," Tucson.com, Sept. 23, 2010, http://tucson.com /news/local/border/border-bolet-n-sheriff-babeu -says-he-doesn-t-endorse/article_534c53f2-c73f-11df -bf47-001cc4c002e0.html (accessed July 3, 2016).

13. "What Donald Trump and Jeb Bush Mean When They Talk about 'Anchor Babies,'" *Deseret News*, August 25, 2015, at http://www.deseretnews .com/article/865635353/What-Donald-Trump-and -Jeb-Bush-mean-when-they-talk-about-6anchor -babies7.html?pg=all (accessed July 3, 2016).

14. "Breitbart: Obama's Accidental Gift on Race," *Washington Times*, July 27, 2009, at http:// www.washingtontimes.com/news/2009/jul/27/the -presidents-accidental-gift-on-race/?feat=home _headlines (accessed September 3, 2016).

15. Theda Skocpol and Vanessa Williamson, *The Tea Party and the Remaking of Republican Conservatism* (New York: Oxford University Press, 2016), 7.

16. Skocpol and Williamson, *Tea Party*, 77–82, 79, 184.

17. Dyson, *Black Presidency*, 110.

18. https://www.splcenter.org/fighting-hate /intelligence-report/2013/year-hate-and-extremism (accessed Sept. 4, 2016).

19. http://hopedespair.yctl.org/category/edited -audio-interviews/ (accessed Sept. 6, 2016).

20. Lepore, *Whites of Their Eyes*, 95.

21. Lepore, *Whites of Their Eyes*, 137. See also Arlie Hochschild, *Strangers in Their Own Land: Anger and Mourning on the American Right* (New York: Free Press, 2016); and Christopher Parker and Matt Barreto, *Change They Can't Believe In: The Tea Party and Reactionary Politics in America* (Princeton: Princeton University Press, 2013)—for their full discussion of white displacement and Obamaphobia, see 153–217.

22. Noam Chomsky, *Manufacturing Consent: The Political Economy of the Mass Media* (New York: Pantheon, 1988).

23. "Fox News makes viewers both more conservative and less informed." Skocpol and Williamson, *Tea Party*, 201.

24. "Muslims, Keep Out: The Republican Campaign against a Ground Zero Mosque," *Slate*, August 2, 2010, at http://www.slate.com/articles/news _and_politics/frame_game/2010/08/muslims _keep_out.html (accessed September 6, 2016).

25. Andy Newman, "In Battle Over Mosque, a Defender of Architecture," *New York Times*, August 4, 2010, at http://cityroom.blogs.nytimes.com /2010/08/04/in-battle-over-mosque-a-defender-of -architecture/ (accessed September 6, 2016).

26. "Ground Zero Mosque Plans 'Fuelling Anti-Muslim Protests across US," *The Guardian*, August 12, 2010, at https://www.theguardian.com/world /2010/aug/12/ground-zero-mosque-islamophobia (accessed September 8, 2016).

27. https://www.splcenter.org/fighting-hate /extremist-files/individual/pamela-geller (accessed September 9, 2016).

28. "Pamela Geller to Obama: 'Excuse Me, Mr. President, But We Speak American Here," *Right Wing Watch*, February 11, 2015, at http://www.right wingwatch.org/content/pamela-geller-obamas

-usurper-presidency-going-be-america-s-greatest
-challenge (accessed September 4, 2016).

29. http://hopedespair.yctl.org/places/nggallery
/galleries/new-york-ny/page/22#gallery/7f2fd7ddf6
2463395b3b8f4120fa72f3/612.

30. Todd Green, "Is America Becoming More
Islamophobic?," *Huffington Post*, June 26, 2016, at
http://www.huffingtonpost.com/todd-green-phd
/is-america-becoming-more-_b_7658942.html
(accessed September 6, 2016); http://www.adl
.org/assets/pdf/combating-hate/Hate-Crimes
-Statistics-2000–2010.pdf (accessed September 4,
2016); Moustafa Bayoumi, *This Muslim American
Life: Dispatches from the War on Terror* (New York:
NYU Press, 2015), 131, 138.

31. Skocpol and Williamson, *Tea Party*, 209.

32. Ken Light, *Witness in Our Time: Working Lives
of Documentary Photographers* (Washington, D.C.:
Smithsonian Books, 2000), 7.

33. Richard Hofstadter, *The Paranoid Style in
American Politics* (1964; repr., New York: Vintage,
2008), 23–24. See also Daniel Bell, "The Dispos-
sessed," in *The Radical Right* (1963; repr., New
York: Transaction, 2001), which Hofstadter was
engaging.

34. Edward Said, *Orientalism* (New York: Vin-
tage, 1978), 37, 38.

35. Patricia Williams, "The Ethnic Scarring of
American Whiteness," in *The House That Race Built*,
ed. Wahneema Lubiano (New York: Vintage, 1997),
262–63.

36. "To American Muslim Kids: Stay Strong
amid Islamophobic Rhetoric," *Chicago Tribune*,
December 22, 2015, at http://www.chicago
tribune.com/news/columnists/ct-muslim-children
-islamophobia-20151222-story.html (accessed Sep-
tember 11, 2016).

CHAPTER 6

1. Milan Kundera, *The Book of Laughter and For-
getting* (1979; repr., New York: Harper Perennial,
1999), 41.

AFTERWORD

1. Walter Benjamin, "N [Re the Theory of
Knowledge, Theory of Progress]," in *Benjamin: Phi-
losophy, History, Aesthetics*, ed. Gary Smith (Chi-
cago: University Press of Chicago, 1989), 50.

Index

CPSIA information can be obtained
at www.ICGtesting.com
Printed in the USA
LVHW061346050123
736372LV00006B/179